Suzanne Stryk, *Looking Backwards*, mixed media [USGS topographic map, clay, modeling paste, acrylic on Mylar, plants, measuring tape], 27 x 21 in., 2012. Stryk created this image with real clay from Thomas Jefferson's Poplar Forest during the production of her series of twenty-six assemblages titled *Notes on the State of Virginia. Courtesy of the artist.*

A GUIDE TO

# THOMAS JEFFERSON'S VIRGINIA

LAURA A. MACALUSO, PHD

THE
History
PRESS

# THOMAS JEFFERSON'S
## —VIRGINIA—

Blue Ridge
Parkway

*Jeffe*

*Omni Hom*
*Resort*

64

*Natural B*
*Pea*

BLACKSBURG

• ROANOKE

77

N

W          E

S

Thomas Jefferson's Monticello & Mulberry Row
James Monroe's Highland
Michie Tavern
University of Virginia
Shadwell, Richmond Road (Route 250)
Thomas Jefferson Center for Historic Plants
(Tufton Farm)
Morven Farm
Blenheim Vineyards
Jefferson Vineyards

66

81 Shenandoah
National Park
James Madison's
Montpelier

95

Barboursville
Vineyards

CHARLOTTESVILLE

The Monacan
Indian Nation
Buckingham County
Courthouse
Tuckahoe Plantation

e Park
r
64

LYNCHBURG
★ RICHMOND
Virginia State Capitol Building

Thomas Jefferson's
Poplar Forest
The James River
WILLIAMSBURG

85
PORTSMOUTH

Wren Building, College of William & Mary
George Wythe House, Colonial Williamsburg
Capitol Building
Governor's Palace

Published by The History Press
Charleston, SC
www.historypress.com

Front cover image: Caleb Boyle, *Thomas Jefferson at the Natural Bridge*, oil on canvas, circa 1801. *Lafayette College Art Collection*. Back cover images: Edward Sachse, *View of the University of Virginia*, lithograph in colors, 21⅞ x 28⅞ in., n.d. *Mabel Brady Garvan Collection, Yale University Art Gallery, 1946.9.394*; John Trumbull, *Thomas Jefferson*, oil on mahogany, 4½ x 3¼ in. (11.4 x 8.3 cm), 1788. *Metropolitan Museum of Art, 24.19.1*.

First published 2018

Manufactured in the United States

ISBN 9781467139199

Library of Congress Control Number: 2018936064

*Notice*: The information in this book is true and complete to the best of our knowledge. It is offered without guarantee on the part of the author or The History Press. The author and The History Press disclaim all liability in connection with the use of this book.

*Charlottesville, Virginia,*
*August 11–12, 2017*

*This is the last stop…it's not so black and white.*

*David J. Matthews and Stefan Lessard, "The Last Stop" (1998)*
*A Concert for Charlottesville, September 24, 2017*

# CONTENTS

♦    ♦    ♦    ♦

*Readers are encouraged to contact each organization before visiting to confirm hours of operation and tour schedules, as well as to learn about special programming and unexpected closings.*

# FOREWORD

I t is one thing to read about Thomas Jefferson, either in his own words or in the history and opinions written by others, but it is an entirely different and far more vivid experience to actually "see" Mr. Jefferson by visiting the scenes and places where he was present. Laura Macaluso's welcomed addition to the already vast bibliography of books about Thomas Jefferson allows one to actually seek out and discover the settings and buildings in which the presence of the man may still be felt.

Herein, Ms. Macaluso's work provides us with a virtual itinerary of places to visit where we may envision Thomas Jefferson in his day-to-day world, from his early childhood through the last years of his life. Her chapters present the places that are both well known and out of the way. Different from many other works on the life of Mr. Jefferson, we become the master within these pages to map our own course in pursuit of a more intimate association with Jefferson and his beloved Virginia. For the first time, many places merely referred to in other books are now more fully revealed both in print and picture, encouraging us to visit these little-known sites connected with Jefferson's life. In so doing, we uncover the veil of the passing of time to see that a majority of sites and locations, with their ageless ambiance, remain unchanged. In these pages, we gain a better sense of place in Jefferson's world; we can grasp more readily his lifelong quest to establish a universal suffrage through educated citizenship.

From his childhood years at Shadwell Farm and Tuckahoe Plantation, through to his adolescence and young adulthood in Williamsburg, Virginia,

Ms. Macaluso takes us to the integral sites of Jefferson's first cognizances and years of early enlightenment, and we enter into the buildings he knew and inhabited. We visit with his friends James Madison, James Monroe, James Barbour and others at their own homes. We become familiar, as he was, with the finest libraries in Virginia and are able to gain a better understanding of the sources for his only published narrative, *Notes on the State of Virginia*. Accordingly, Ms. Macaluso provides us with the information to visit the settlements, cities, towns, mountains and rivers, along with the resources for references within Jefferson's *Notes*, to become familiar with the flora and fauna of Virginia and the diversity of population within the former colony and young Commonwealth of Virginia.

Best of all, we are able to have an in-depth visit at Poplar Forest, Mr. Jefferson's "Retreat House," where he went to escape the onslaught of "curiosity seekers" who besieged him at Monticello. It was at Poplar Forest that Jefferson could feel the most intimate and secure with family and friends, a place where he said, "I may go to read, to write, but most importantly, a place where I may think." Imagine the need in Mr. Jefferson's mind to get away in the four-mile-per-hour world in which he lived, simply to be able to think more profoundly. At Poplar Forest, we are able to see that more private Mr. Jefferson. We are better able to acquaint ourselves with the man as a "private citizen" and his innate love of agriculture, husbandry and his lifelong pursuit of maintaining good health.

This work is complete with directions and information on the final resting places of Thomas Jefferson and his friends. This supports the sentiments of Jefferson, the man, in his wishes to be buried among his native woods and fields, for nowhere else could take its place. Laura Macaluso's book helps us to take our place in Thomas Jefferson's Virginia. It prepares us well and supports our journey into the private world of a man who was a living legend in his own times. For those who have yet to be introduced to Thomas Jefferson, may this book prove a happy meeting. For those already grounded in Jefferson studies, may this be a delightful refresher and open new doors for a more intimate relationship with the man and the myth.

BILL BARKER

# PREFACE

T here is a place called "Jefferson Country." I first learned of it when my husband accepted a position working for Thomas Jefferson's Poplar Forest in 2012. As Connecticut Yankees, we were unexpectedly part of a network of places associated with this iconic man and his life and legacy in the Piedmont region of central Virginia. As it turns out, Jefferson Country is both a geographic locale and a sensibility about what it means to be a Virginian—and an American. Thomas Jefferson himself is behind this approach to living and appears in all sorts of circumstances, from historic sites to the names of plazas—and even to the name of a burger on the menu of a local restaurant. There are bronze monuments, historic markers and paintings of him everywhere, not to mention numerous historic sites and landscapes associated with him, many of which are the subject of this book. His memory and presence is curated and cultivated in central Virginia and represents an idealized version of living via the Enlightenment, with an emphasis on education, reasoned thinking and an appreciation for nature.

Jefferson Country is not without its problems, however. Within the picture of refined red brick buildings with creamy white classical columns and against the verdant rolling landscape and the Blue Ridge Mountains, there are generations of people for whom the phrase "Jefferson Country" meant only enslavement and, later, a life constrained by post-Reconstruction practices that pulled back on new freedoms for African Americans and created a segregated society that lasted another one hundred years, the effects of which everyone struggles with today.

# THE ENLIGHTENMENT

*Bigotry is the disease of ignorance, of morbid minds; enthusiasm of the free and buoyant. Education and free discussion are the antidotes of both. We are destined to be a barrier against the returns of ignorance and barbarism. Old Europe will have to lean on our shoulders, and to hobble along by our side, under the monkish trammels of priests and kings, as she can. What a Colossus shall we be when the Southern continent comes up to our mark! What a stand will it secure as a ralliance for the reason & freedom of the globe! I like the dreams of the future better than the history of the past. So good night. I will dream on, always fancying that Mrs. Adams and yourself are by my side marking the progress and the obliquities of ages and countries.*

—*Thomas Jefferson to John Adams from Monticello, August 1, 1816*

What is one way to understand the life of Thomas Jefferson and the world in which he lived? In a word, the Enlightenment. This word refers to "a state of being enlightened" according to Noah Webster, who created the first American dictionary in 1828, just two years after Jefferson's death—an Enlightenment project in and of itself that he would have appreciated. Above all else, Thomas Jefferson is a model of Enlightenment thinking, and this, in combination with his deep love for Virginia, created a special sensibility that permeates the places he lived because of the way he lived his life. Today, people visit these places—especially Monticello, the University of Virginia and Poplar Forest—to find this special sensibility, which had its roots in the Enlightenment.

Western European in origin, the characteristics of the Enlightenment include a search for knowledge about the past and the use of reason and firsthand observation to understand the world in new ways, away from superstition and a reliance on religion. If you think about the characteristics of Enlightenment thinkers—collecting books and objects, organizing material culture within systems, writing new histories, traveling for knowledge, asking questions and searching for answers, taking measurements and making comparisons—Thomas Jefferson did all of these things and more, demonstrating his complete adherence to Enlightenment thinking, to Enlightenment being. Because he was also an architect, Enlightenment philosophy and approach to life is literally built into the Virginia landscape, providing us today with concrete (or brick,

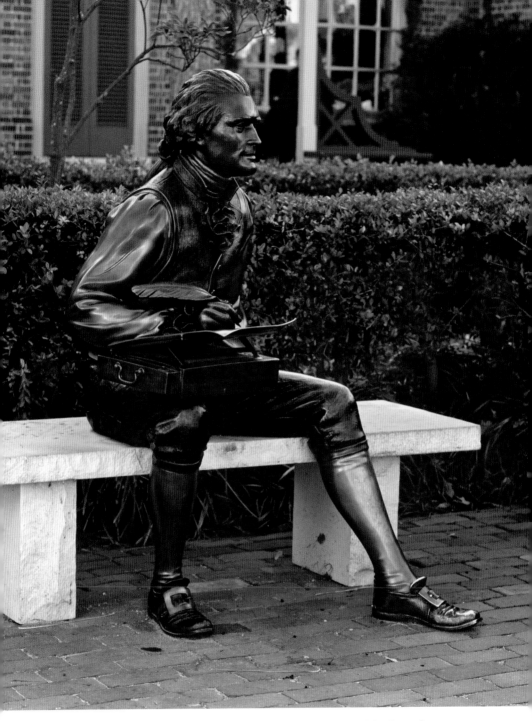

Thomas Jefferson statue, bronze, sculptor George Lundeen, 1999, Merchants Square, Williamsburg. *Courtesy of the Colonial Williamsburg Foundation.*

wood and mortar) objects through which to understand how much the Enlightenment shaped his approach to living and how this imprint can be seen across Virginia.

This book is an introduction to Thomas Jefferson's life and legacy in Virginia through the buildings, landscapes and objects associated with him and with the people in his direct orbit. The book is about the symbiotic relationship of a person and a place, something that contemporary Commonwealth residents and visitors begin to see and feel with time spent here. Walking up the Blue Ridge Mountains or

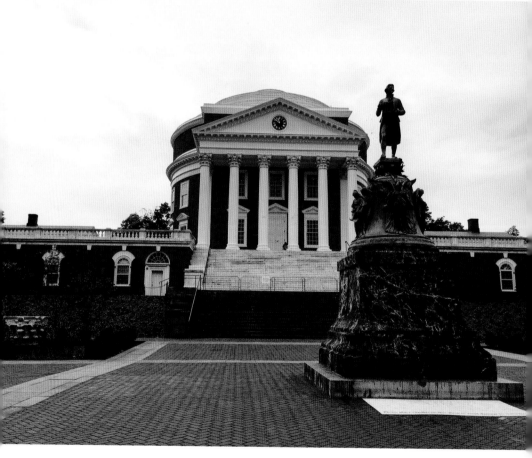

Thomas Jefferson Monument in front of the Rotunda, Moses Ezekiel, 1910, University of Virginia. *Author's collection.*

along the Appalachian Trail, standing on the banks of the James River, watching bateaux float downriver from Lynchburg to Richmond, visiting old tobacco barns in open fields, seeing the tall grasses cut twice a year and eating country cooking that stems from an amalgamation of rural life and African American foods (which, in turn, were influenced by West African traditions)—all this and more can be experienced in Virginia, especially in Jefferson Country. There are blue skies and green grasses, a lot of cows, Monarch butterflies and turkey buzzards, black bears and deer. Central Virginia is also home to more Southern Baptist churches, Confederate flags and food, wine and music festivals than I can count. The atmosphere is homey, and Virginians are, generally, both conservative and courteous. Hence one of the reasons why the events in Charlottesville in August 11–12, 2017, were so appalling.

A white supremacy rally appeared on the campus of the University of Virginia, surrounding the bronze statue of Thomas Jefferson in front of the Rotunda with Tiki-torch light on Friday night, August 11, 2017. The next day, during an anti-hate rally in response to the evening before, a thirty-two-year-old woman died when a car was purposefully driven into the crowd of these peaceful protestors. What happened in Charlottesville is not endemic to Jefferson's city alone, but events take on special meaning due to Jefferson's presence there and the uses to which history is actively set as a tool for both positive and negative actions. In the spirit of Jefferson's words to his friend and fellow revolutionary John Adams, together we can actively work to ensure that the United States bolsters its commitment to the Jeffersonian view that "[w]e are destined to be a barrier against the returns of ignorance and barbarism."

Jefferson's status as a slave owner and father of enslaved children has diminished his standing in the pantheon of important Americans, a reflection of the awareness we now have of the fullness of history, as well as how that fullness—which is the good and the bad—has shaped the institutions, cultural practices and beliefs of the present day. In the case of Thomas Jefferson and slavery, one cannot but help to ask the questions: What if Jefferson had been able to overcome his own familial and cultural heritage and his economic problems and freed the people he kept enslaved? What if he had not turned away later in life from his own words, excised from the Declaration of Independence to appease northern and southern financial interests, that the slave trade was an "execrable commerce" and an "assemblage of horrors"? Would

American society have charted a different course if the author of the Declaration of Independence and the Virginia Statute of Religious Freedom had argued harder or done things differently in his personal life? I suppose imagining what might have been is generally a useless endeavor. What might have been is not what happened, so where does that get you? Jefferson had a choice, and he chose not to; we still struggle to understand why this profound practitioner of the Enlightenment in America turned away from what he knew was grievously wrong.

I don't know yet how to bridge that chasm between all the good things Jefferson did—and they were groundbreaking and shaped each of our lives—and also come to terms with his choice to profit from keeping men, women and children enslaved, six of them his own children with Sally Hemings. But I do think that if any place can and should work to address this chasm in the United States, it is the Commonwealth of Virginia and it is the person and subject of Thomas Jefferson. Fortunately, the people and places preserving and interpreting Jefferson, such as Monticello and Poplar Forest, strive to do this work—and they do it for all of us, leading conversations and presenting information that sometimes still bumps up against an older view of the interpretation of Jefferson in his lofty position on a pedestal. If you want to see in visual, concrete terms how much the presentation and interpretation of Jefferson has changed, look at two particular bronze statues. One, previously mentioned, on the campus of the University of Virginia, has Jefferson's pedestal so high it's actually difficult to see the details. The other example, of a bronze Jefferson sitting on a park bench in Williamsburg, encourages viewers to sit with him as he writes, a daily practice to which he devoted countless hours. In the almost one hundred years separating the creation of these two bronze statues of Jefferson, American culture has changed, and so, too, has the interpretation of history.

A second example, for more critical comparison, is two more bronze monuments, both in Washington, D.C., not far from Jefferson Country. The earlier monument, the Jefferson Memorial, features an oversized bronze figure standing in an oversized open-air rotunda. Across the Potomac on the National Mall, in the newest museum in the Smithsonian Institution system, the National Museum of African American History and Culture, a bronze statue of Thomas Jefferson stands surrounded by his own words about liberty and freedom, as well as the names of the men, women and children he kept enslaved during the course of

his long life. In this era of critical thinking and the inclusion of ever-widening histories of those whose contributions were once marginalized or actively erased, Thomas Jefferson is not less important to know—he is more important than ever. He is a symbol of the paradox inherent in the American character and American history.

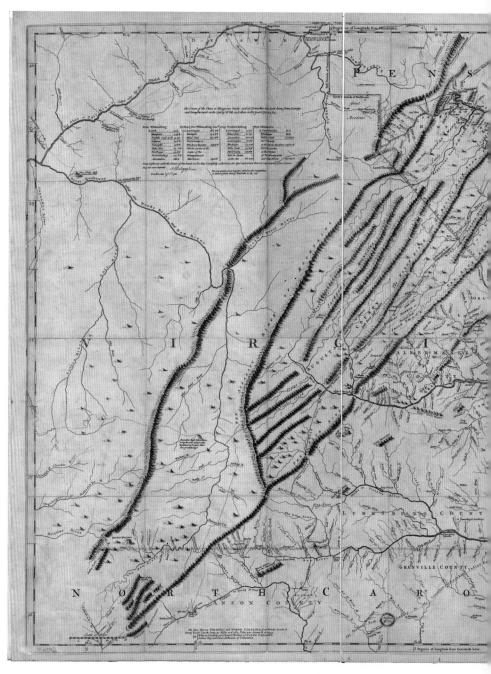

Joshua Fry and Peter Jefferson. *A Map of Those Most Inhabited Part of Virginia Containing the Whole Province of Maryland with Part of Pensilvania, New Jersey and North Carolina.* Published by Thomas Jefferys, London, 77 x 124 cm. Drawn in 1752, reprinted in 1775. *Courtesy of the Library of Congress.*

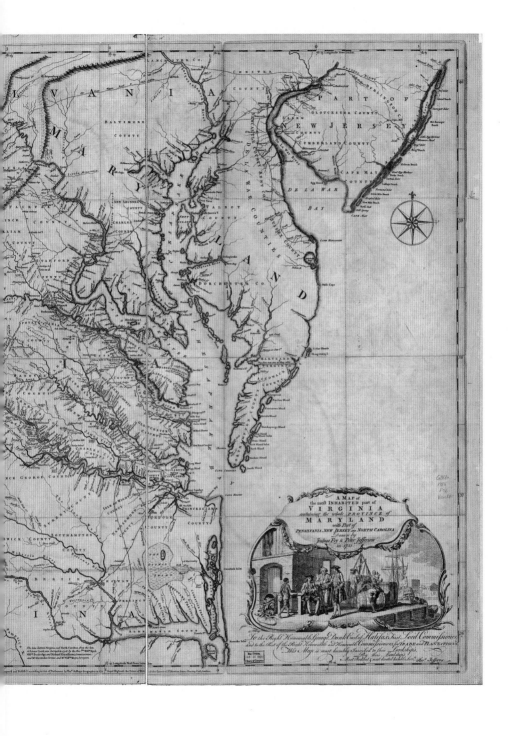

# JEFFERSON'S YOUTH

## A MAP OF VIRGINIA, SHADWELL AND TUCKAHOE

*On the whole I find nothing any where else in point of climate which Virginia need envy to any part of the world....Spring and autumn, which make a paradise of our country, are rigorous winter with them* [New Englanders].*...When we consider how much climate contributes to the happiness of our condition, by the fine sensations it excites, and the productions it is the parents of, we have reason to value highly the accident of birth in such an one as that of Virginia.*
—*Thomas Jefferson to Martha Jefferson Randolph, May 31, 1791*

Let's start with this map—a large paper map, hand-colored and located at the Library of Congress in Washington, D.C. This map, so big that it was created out of multiple pieces of paper, measuring in total 2.5' x 4', was the product of two men surveying the far reaches of a place called Virginia. Located on the eastern Atlantic shore of North America and stretching across plains and rolling hills to the range of Appalachian and Allegheny Mountains to the west and the land beyond, Virginia was the first English settled colony in the Americas. Named for the English Queen Elizabeth, the "Virgin Queen," this colony, later called a commonwealth (as is Massachusetts, the second such colony), was founded in 1607, just four years after Elizabeth's death. What is clear from viewing this map is that the place called Virginia was not only buttressed by the ocean to the east and the mountains to the west but also was, and is, characterized by the number of rivers and creeks that spread like veins across the map and surface of the landscape. This water-rich land lent itself to agricultural development, and the longest and deepest waterways—the Fluvanna

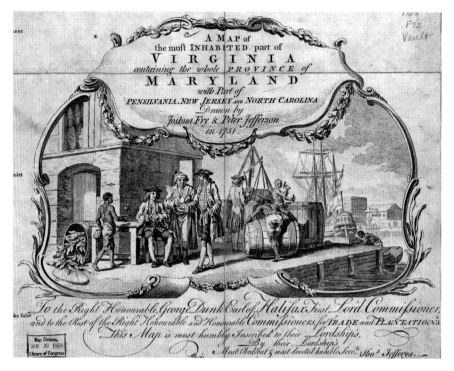

Detail, cartouche of the map of Virginia by Joshua Fry and Peter Jefferson. *Courtesy of the Library of Congress.*

and Rivanna Rivers and the James River, all of which were important to the indigenous people and later development of central Virginia— provided the first generations of British subjects a transportation route for their agricultural goods. The Allegheny, Appalachian and Blue Ridge Mountains, as seen on the map in 1755, halted settlement beyond the mountains, at least for a time. Travel was too difficult for people, animals and supplies, and safety was an issue.

What most people often miss when viewing such historic and impressively sized maps are the cartouches that contain information about who the map was made for, by whom and when. Cartouches can be simple or elaborate, but they each contribute to the information presented on the map. The cartouche here shouldn't be ignored, as it contains a drawing that was later engraved and printed as part of the map, serving as a symbol for a narrative of Virginia in the eighteenth century. This is a representation of the Virginia that Thomas Jefferson was born into in 1743, thus understanding the symbols and meanings in the drawing helps us to place

young Thomas, the first son of Peter Jefferson (1708–1757), a surveyor, mapmaker, farmer and legislator, into the society and cultural practices developing on that land. Peter Jefferson finished the map when Thomas was nine years old; his father's work, over the course of many years, to survey the land and help draw the map with his instruments influenced the future architect/statesman/president. While Thomas Jefferson would never design anything so large as this groundbreaking map—the second-earliest map of Virginia after Captain John Smith's 1612 map—Jefferson himself did draw maps and broke ground in other ways, building in three dimensions and thus taking his father's work beyond pen and paper.

Under the flowery title in the cartouche, a scene unfolds that tells us many things about Virginian culture in the eighteenth century. What are some of the things you see? First noticed, perhaps, is the location. The mini-narrative takes place on a wharf, and a tall-mast ship is seen in the distance to the right. Three white men grouped together in the center of the scene are talking, and one smokes. The men at the right and left are wearing fine clothes, with vests, jackets and tricorn hats. The man in the middle is heavy, and he wears a puffed hat and a silk coat, looking very much like the subject from a John Singleton Copley portrait. These men are not shown physically working—they are the merchant and planter classes of Virginia, likely the owners of ships and/or plantations represented here who are the elite members of society. Many, like Peter Jefferson, were officeholders due to their landowning status.

There are other men around them working, and here are shown two other classes in eighteenth-century Virginia society: the lower, working class of managers and administrators and a group of people not classified as citizens at all, but as property: enslaved men, who serve drinks and pack and move "hogsheads," which are large barrels packed with tobacco from Virginia plantations. You can see the barrel to the left with tobacco leaves spilling out. The abundant and profitable crop that also depleted the soil of its nutrients—something Thomas Jefferson discovered on his own plantations and worked to rectify—is here a selling point for the status and development of the Virginia colony. The setting for this cartouche narrative is a tobacco warehouse on a wharf on the Chesapeake. Tobacco from the interior of Virginia would be shipped on bateaux (long flat-bottomed boats) down the James River, to the mouth of the Chesapeake Bay and out across the Atlantic. Most of these working wharves built of heavy stone blocks up and down the Atlantic coastline are gone today, but you can find some sense of wharves on the water if you visit Savannah, Georgia.

# SHADWELL

*Thomas Jefferson—author of the Declaration of Independence, third president of the United States, and founder of the University of Virginia—was born near this site on 13 April 1743. His father, Peter Jefferson (1708–1757), a surveyor, planter, and officeholder, began acquiring land in this frontier region in the mid-1730s and had purchased the Shadwell tract by 1741. Peter Jefferson built a house soon after, and the Shadwell plantation became a thriving agricultural estate. Thomas Jefferson spent much of his early life at Shadwell. After the house burned to the ground in 1770, he moved to Monticello, where he had begun constructing a house.*

*—Virginia Historical Highway Marker, 2002*

Peter Jefferson is part of this map's story, not only as the surveyor and mapmaker but also as a landowning Virginian. His son, Thomas Jefferson, was born into this story on April 2, 1743, on his father's farm called Shadwell in central Virginia (Jefferson's birth date would later be moved up to April 13 when the British empire selected the Gregorian calendar over the Julian one). Peter had begun purchasing land in the mid-1730s that was named for the London parish where his wife was born. This area of central Virginia, seen on the map in Albemarle County, was in the Piedmont, near the Rivanna River. Thomas was the second child—but first son—of Peter and Jane Jefferson, and as Virginia practiced primogeniture, the tradition of giving the firstborn son all of a family's wealth and inheritance, he inherited Shadwell and had a choice of more properties upon his father's death. Peter Jefferson's property included land as well as slaves, a fact not listed on the historic marker that notes that Shadwell "became a thriving agricultural estate." Dying in 1757 when Thomas was fourteen, in his will Peter gave his son the choice of two properties in addition to Shadwell. Thomas chose lands not far from his parents' house, which at the time (and still today) comprised two small mountains called Monticello and Montalto. Jefferson already loved walking the little mountains up and down—the beginnings of his love for nature and his dedication to daily exercise—but they also served as a quiet place of repose for reading, which he often did with his boyhood friend Dabney Carr.

Shadwell today is identified by the Virginia Historical Highway marker, but there is little to see beyond the tangled bushes that grow on both sides of Richmond Road. Jefferson might have stayed in the family home after

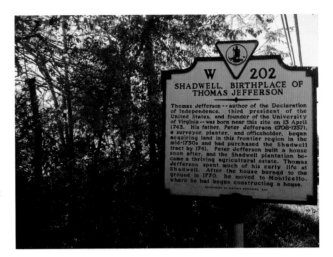

"Shadwell, Birthplace of Thomas Jefferson" marker, Virginia Department of Historic Resources, 2002. This marker replaced an earlier version. *Author's collection.*

marrying the young widow Martha Wayles Skelton (his third cousin) in 1772, but the house at Shadwell had burned down in 1770, around the same time he was beginning to build his own home, the first Monticello. Shadwell remained in Thomas Jefferson's hands until his death—it was one of his working sub-farms of Monticello that were called at the time "quarter farms." Shadwell was also the location of two state-of-the-art mills, which processed the wheat and rye grown by the enslaved community at Jefferson's farms.

To visit the Shadwell historical marker, take Richmond Road (Route 250), east of Exit 124 (Interstate 64), Charlottesville, Virginia, 22911 (or 38° 0.906′N, 78° 24.948′W). The marker can be seen anytime day or night and is near the intersection of Route 250 and Route 22. Not far away is a second historical marker for Edgehill Plantation, where Thomas Mann Randolph lived before marrying Martha Jefferson, the daughter of Thomas and Martha Jefferson. Cornelia Jefferson Randolph, Thomas Jefferson's granddaughter, was an amateur artist, operating a ladies' school out of Edgehill with her sister Mary in the 1830s and 1840s.

## TUCKAHOE

*Perhaps the oldest frame residence on James River west of Richmond, Tuckahoe was begun about 1715 by Thomas Randolph. The little schoolhouse still stands here where Thomas Jefferson began his childhood*

*studies. Famous guests here have included William Byrd of Westover, Lord Cornwallis and George Washington. Virginia's Governor Thomas Mann Randolph was born here.*

—*Virginia Historical Highway Marker, 1951*

Although there is little to be seen at Shadwell today, at least for those who haven't studied archaeology or historic landscape architecture (identifying and reading landscape features), another site from Jefferson's youth stands intact farther east, about fifty miles from Charlottesville. Tuckahoe, a plantation in Goochland and Henrico Counties outside Richmond, was home for Peter Jefferson and his family for seven years between 1745 and 1752, when Thomas was age two through seven.

The depths at which Jefferson family members and friends cared for one another—a trait that would become ingrained in Thomas—are apparent when learning the story of why the Jeffersons left Shadwell for Tuckahoe. William Randolph and his family lived at the Tuckahoe Plantation, and William's cousin Jane married Peter Jefferson. William's wife, Maria, had died in 1744, and William himself died the following year, leaving three children alone. Before he died, though, William specified in his will that he wished his good friend Peter Jefferson to come live at Tuckahoe with his family until his son was old enough to assume responsibility for the family. Peter Jefferson did as he was asked and brought Jane, Thomas and three daughters to live at Tuckahoe with the three orphaned Randolph children.

The Tuckahoe Plantation as it stands today is centered on the central house, a wood-frame two-story *H*-shaped structure. This is where all the Jeffersons and Randolphs resided together. Outside the house is a series of outbuildings including a kitchen house, quarters for the enslaved community, a smokehouse, a storehouse, stables and, of interest especially to the story of Thomas Jefferson, a small structure that served as a one-room schoolhouse for the Jefferson and Randolph children. Outside, farther from the house, are cemeteries for the Randolph and, later, Wight families— and even today for the contemporary owners of the property as well. In rural

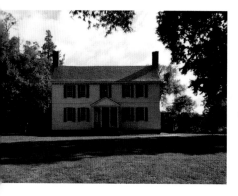

Tuckahoe Plantation, central house.
*Photograph by Jeffrey Nichols.*

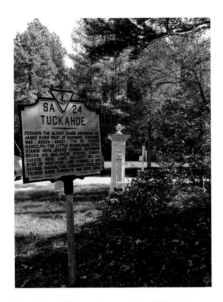

Tuckahoe Plantation marker, Virginia Department of Historic Resources, 1951. *Author's collection.*

Virginia, burial close to one's home is common, both for elite members of society and for farmers and others. As seen in the last chapter of this book, Thomas Jefferson and members of his family were buried on the grounds of Monticello, within walking distance of the house. Enslaved people were also buried on the grounds near which they worked and lived, although separately from the whites and often in more secluded, even secretive spots, usually without gravestones.

The one-room schoolhouse of white painted clapboard, just like the central house, was once marked with a bronze plaque that read, "Over these grounds and to his schoolhouse came the child Thomas Jefferson and here the noble discipline of his mind began"—placed there by the Daughters of the American Revolution in 1876, the centennial year in which all things Revolutionary were dusted off and celebrated. Thomas Jefferson was actually a distracted student, although he loved books and reading—another trait inherited from his father. It was only later, as an adult, that Jefferson's "noble discipline of mind began," thanks to maturity and meeting mentors who shaped his learning in Williamsburg. Jefferson's earliest educational experiences, which continued after the family left Tuckahoe to return to Shadwell, contributed to his professional success. In rural areas of Virginia, only those houses with large book collections could offer the kind of learning the Jefferson family desired for their son. As an adult, Jefferson recognized this and dedicated himself to education, first his own; later his grandsons' and granddaughters', as well as, to a limited degree, that of the enslaved people he owned, whose education was in service to property owners such as himself; and, finally, that of Virginia and the country through the formation of a public university separate from the educational institutions built on theocracy such as Harvard or Yale or the divine rights of kings such as King's College (today Columbia University) or William & Mary.

Tuckahoe today reflects the southern trend of turning plantation homes and grounds into event venues, often for weddings. For many, this is a

problematic development that, on the one hand, serves to keep historic houses and grounds intact in the midst of the continual slicing and dicing of agricultural land for housing and commercial development, a trend that is running full steam ahead in the South. On the other hand, these places hold histories and memories that many people fail to grasp—generations of enslaved men, women and children lived, worked and died at plantations such as Tuckahoe, and American society at large often forgets this when caught up in contemporary, pleasurable events. When working with historic places, there are often contradictory positions to grapple

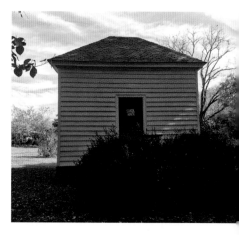

Schoolhouse on the Tuckahoe Plantation. *Author's collection.*

with, and we must ask ourselves important questions: What is possible here, and what is appropriate here? Not every historic place can, or should, become a museum, but where are the lines drawn? Visit any plantation in Virginia—and there are many of them open to the public, such as Berkeley or Shirley Plantations, in addition to plantations associated with Thomas Jefferson such as Tuckahoe—to see for yourself.

To see the Tuckahoe historical marker, head toward Richmond, Virginia, to Goochland County. The marker is on River Road (Virginia Route 650), 0.2 miles west of Blair Road (Route 649), on the left when traveling west. The marker is near 12601 River Road, Henrico, Virginia, 23238 (37° 34.954′N, 77° 39.207′W). To visit Tuckahoe Plantation, make an appointment to see the interior of the house and take a history tour, otherwise there is an honor system whereby you can drop five dollars in a box and tour the grounds and gardens by yourself. The address is 12601 River Road, Richmond, Virginia, 23238.

# JEFFERSON'S HIGHER EDUCATION

## THE COLLEGE OF WILLIAM & MARY, THE GEORGE WYTHE HOUSE AND THE UNIVERSITY OF VIRGINIA

*Knowledge indeed is a desirable, a lovely possession.*
*—Thomas Jefferson to his grandson Thomas Jefferson Randolph,*
*August 27, 1786*

In the Commonwealth of Virginia, locals can often be seen wearing college colors. Half of the state wears the gear of the Virginia Polytechnic Institute, or "Tech," and the other half that of the University of Virginia, or "UVA." It is a rivalry long and enjoyable for those alums, but the fact of the matter is that Virginia is proud of its role in the development of education in the United States, an important role beyond the winning of football games between Hokies and Hoos. Virginia is home to the country's second-oldest institution of higher education—the College of William & Mary, founded in 1693, which follows Harvard University but precedes Yale University—and to a powerhouse example of the public university system in the United States in the form of the University of Virginia, founded in 1819 by Thomas Jefferson himself. That Jefferson attended William & Mary (today one of eight so-called Public Ivy League schools) tells us about the desires and financial status of his family and guardians to create opportunities for their eldest son. That he wanted to offer others similar opportunities through formal education says much about the importance of learning to Jefferson, a personal trait that would never escape him—never more so than when he became an elderly man on the mountain, looking down at his university nestled in the town of Charlottesville below him.

# THE COLLEGE OF WILLIAM & MARY

*[B]y going to the College I shall get a more universal Acquaintance, which may hereafter be serviceable to me; and I suppose I can pursue my Studies in the Greek and Latin as well there as here, and likewise learn something of the Mathematics.*

*—Thomas Jefferson to John Harvie, January 14, 1760*

In 1760, at the age of seventeen, a young Thomas Jefferson—tall, lean, red-haired and a good dancer, thanks to his sister—traveled from Shadwell to Williamsburg, Virginia, to enter the College of William & Mary. This was a typical pattern for elite young men from around the American colonies. In Connecticut, young Nathan Hale, later to become famous for being the first American spy caught and hanged during the Revolution, went from his father's farm in Coventry to Yale College in New Haven, while those who couldn't afford the fees—including another Revolutionary figure, Benedict Arnold—became apprentices and went to work in trades that offered advancement, allowing some to step into "polite" society.

In the eighteenth century, obtaining higher education was a privilege reserved for only a few. Thomas Jefferson himself would help drive the change leading to higher education for all by founding the first secular public university in the United States. Although women, people of color and even white men from the working class were not part of his original view of the university (or of public life, for that matter), what grew out of Jefferson's original vision is a democratic system of public education based not on family or class or finances but on merit. Generations of American and international students have made good use of public college and university education in the United States, from community colleges to four-year land grant institutions to the public ivies.

The fact that Jefferson was able to go to college after his father's death three years earlier indicates that the family was well off enough to allow the eldest son to leave the family home, pay tuition fees and not work for two-plus years. Peter Jefferson had indeed made provisions for Thomas to receive a "thorough classical education," which was a hallmark of the gentry class. Peter Jefferson died slowly over the course of the summer months of 1757, leaving plenty of time to think about his son's education, which, according to him, should not ignore the "exercise requisite for [Thomas's] bodies development." Once again, Thomas's father hugely affected his

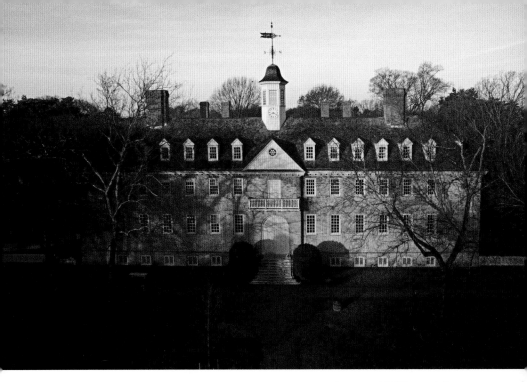

The Sir Christopher Wren building on the Ancient Campus, College of William & Mary, Williamsburg, Virginia. *Courtesy of the Colonial Williamsburg Foundation.*

son's life—not only in providing for a classical college education but also in suggesting that use of the body was equally important to that of the mind. Thomas Jefferson took both things to heart, although it can be argued that he felt the well-being of the body was most important of all. In a letter from 1785, Jefferson wrote, "Encourage all your virtuous dispositions, and exercise them whenever an opportunity arises, being assured that they will gain strength by exercise as a limb of the body does, and that exercise will make them habitual....Give about two of them [hours] every day to exercise; for health must not be sacrificed to learning. A strong body makes the mind strong."

When Jefferson decided that he wanted to attend the College of William & Mary, with his father gone, he asked his guardians—one who watched his finances and another who watched over his development personally—for permission, which was granted. The College of William & Mary was not Jefferson's first experience living away from home for education. After the family returned from Tuckahoe to Shadwell, Jefferson was sent to Reverend James Maury's Latin School, where a small group of boys, including Dabney Carr, studied together. Jefferson and the other young men returned to their homes during holidays. They were all preparing

to enter college, and when Jefferson traveled by horse to the College of William & Mary, he took with him his personal enslaved assistant (called a "body servant"), a young African American man of similar age named Jupiter. When Jefferson arrived, he would have entered the Wren building, the central brick structure on campus, possibly designed by Sir Christopher Wren, the architect of St. Paul's Cathedral in London, famous for being rebuilt by Wren after the Great Fire of London in 1666.

Consider for a moment Wren's design for the college building. Built of brick between 1695 and 1700 (making it the oldest college building in continuous use in the United States) in what is called Flemish bond, the style of the Wren building is English and northern European in origin. In addition to the variegated brickwork, the Wren building has rounded arches and Palladian windows, in an amalgamation of English Baroque and Neoclassical taste. Although Wren himself never visited the Colony of Virginia, he was said to have modeled the plan for William & Mary. The Wren building in Jefferson's time contained all the necessities for study: a refectory (or dining hall), classrooms, offices and a chapel, added in 1732. On the top of the building is a distinctive weathervane with the year "1632" cut out in the metal, which was the year of the college's founding.

Like others of his generation and class, Thomas Jefferson did not stay enrolled long enough for an official "graduation." Students like him took as much education as thought needed and moved on to other pursuits to finish their liberal arts education with professional studies, which for Jefferson meant the law. At William & Mary, Jefferson spent two years under the tutelage of Dr. William Small, a Scottish-born professor who helped direct the young man's mind toward logical positions put forward in Enlightenment thought. Academic disciplines based in language and logic, such as math—a subject that for Jefferson was a personal favorite— were emphasized. Further, Small introduced him to George Wythe, who would soon become Jefferson's law tutor. When Jefferson left the College of William & Mary in 1762, it would not be his last association with his alma mater: two wings were added onto the original core structure of the Wren building, and later, Jefferson submitted plans for adding a fourth wing, which would complete the quadrangle and create an enclosed courtyard. However, by that time, the American Revolution had come about, and both Jefferson and the funds needed were directed toward other activities, although foundations for Jefferson's wing were built.

The importance of the Wren building and its location in Williamsburg— the capital of the Virginia colony—meant that the building often played

a supporting role in legislative history. The capitol burned several times, and the burgesses and legislators moved into the Wren building while the capitol was being rebuilt. Jefferson and other William & Mary students would drop in to watch the legal proceedings. Decades later, after studying at William & Mary and obtaining his law degree under the tutelage of George Wythe, Jefferson designed a new capitol building for Virginia—this time in Richmond in a pure Neoclassical style, which he deemed the most appropriate for the new country. In other words, in viewing the Wren building today, you see an architectural style that references England and Virginia's status as a (far-flung) part of the British empire. Another place to see such early architecture in Virginia is Bacon's Castle, in the county of Surrey. Examples of Flemish bond in the United States are few and far between, thus the Wren building, with its academic and legislative history and connections to figures such as Thomas Jefferson and three other United States presidents (James Monroe and John Tyler studied there, while George Washington was a chancellor), is worth visiting, especially in connection with Colonial Williamsburg, which is next door and has more Jefferson sites to see.

Although students still use the Wren building for classes and activities, Colonial Williamsburg has an exhibition on the first floor for visitors. The College of William & Mary calls the Wren building the "soul" of its colonial campus, which is also referred to as the "Ancient Campus," consisting of three buildings—the Wren building, Brafferton (1723) and the President's House (1732)—all of which were part of the college when Jefferson was a student there. You can do a self-guided tour using the W&M mobile app or print out a paper map to take with you (for both, see http://www.wm.edu/about/visiting/index.php). The Ancient Campus welcomes visitors and is in walking distance of both Colonial Williamsburg and shopping at Merchants Square. The main campus address is Sadler Center, 200 Stadium Drive, Williamsburg, Virginia, 23185. If you enter the Wren building, after viewing the exhibit on the first floor, be sure to also view the original lecture hall on the first floor; the second-floor grand hallway, with its collection of portraits; and the numerous historic plaques installed on the exterior of the rear façade.

# THE GEORGE WYTHE HOUSE

*Mr. Wythe continued to be my faithful and beloved Mentor in youth, and my most affectionate friend through life. In 1767, he led me into the practice of the law at the bar of the General Court.....No man ever left behind him a character more venerated than G. Wythe.*

—*Thomas Jefferson, "Notes for the Biography of George Wythe,"*
*August 31, 1820*

After his studies ended at the College of William & Mary, Thomas Jefferson decided to continue his education, but he needed a seasoned and respected mentor to do so—especially if he was going to pass the bar exam and become a lawyer. In Williamsburg, the center of educational, cultural and legislative life of the Virginia colony, lived one George Wythe (1726–1806, pronounced "with"), a scholar of law who took Jefferson on as a student of law beginning in 1762. At first, Jefferson studied with Wythe in his brick house, which stands today on the Palace Green in Colonial Williamsburg. But in order to prevent the distractions of Williamsburg from taking too much of his time—the theater, music and dancing were common occurrences—Jefferson eventually went home to Shadwell to continue his studies, though still under Wythe's guidance. Jefferson studied with Wythe for three years, passing the bar exam in 1765. All of the activities he dedicated himself to while in Williamsburg—such as clerking, studying philosophy, history and political science, as well as listening to the debates and speeches at the House of Burgesses—translated into a reservoir of words, ideas and actions that Jefferson would pull from in the next decade, when he became embroiled in the lead-up to the American Revolution.

After passing the bar exam, Jefferson was able to practice law in the county court system, although he had his sights set on the General Court of Virginia in Williamsburg, the highest court in the Colony of Virginia. His mentor, George Wythe, was a member of the House of Burgesses, acting for more than twenty years as the attorney general for the Colony of Virginia. Jefferson was admitted the following year and became its youngest member. He then went on to practice law in the courts until 1774, when Americans began forcefully speaking out against the practices of the British empire, as Thomas Paine's pamphlet *Common Sense* would suggest. Not surprisingly, George Wythe, the man who had shared the writings of John Locke with Thomas Jefferson, went on to sign (the first of seven Virginians to do so) the

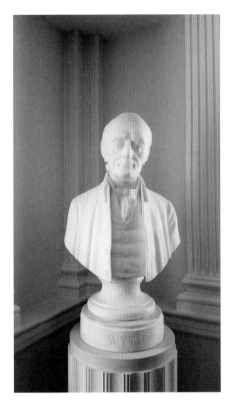

*Left*: Bryant Baker, *Bust of George Wythe*, marble, 1962. Presented by the National Society of Colonial Dames of America in the Commonwealth of Virginia. Virginia State Capitol Building, Richmond. *Photograph by Jeffrey Nichols*.

*Below*: The George Wythe House, circa 1750s, possibly designed by Richard Taliaferro. George Wythe and his wife, Elizabeth Taliaferro, lived here for more than thirty years. *Courtesy of the Colonial Williamsburg Foundation*.

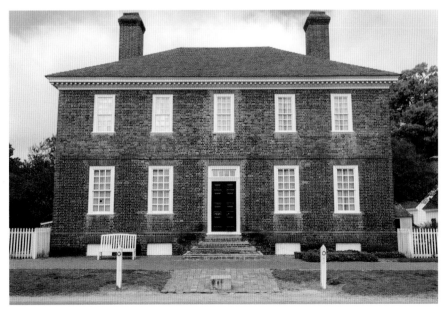

Interior, second floor, George Wythe House. Note the placement of the Fry-Jefferson map of Virginia over the fireplace. *Author's collection*.

most famous document in the history of the western world: the Declaration of Independence, written by his one-time student, Thomas Jefferson.

What *is* a surprise is the way George Wythe died. In 1806, Wythe died by poisoning, either in his coffee or in his strawberries at breakfast. Although not conclusively proven—no one went to jail for the crime—today scholars believe that Wythe was intentionally poisoned by his grandnephew George Wythe Sweeney. He is buried in the graveyard of St. John's Church in Richmond, where Patrick Henry gave his speech "Give Me Liberty, or Give Me Death."

Wythe's house is worthy of visiting for his personal connection to Jefferson, but he also gave more to Virginia itself: he helped to design the Virginia state seal, still in use today, which features the personification of Virtue standing with a sword raised while standing on the figure of Tyranny. The words *Sic semper tyrannis* underneath translate to "Thus always to tyrants." A marble bust of Wythe sits in the state capitol building in Richmond—the building designed by Thomas Jefferson—attesting to his many contributions to Virginia.

You can visit the George Wythe House at Colonial Williamsburg either by walking the Duke of Gloucester Street and viewing the house from the exterior or by buying a day pass, which will enable you to go inside the house, which is sometimes staffed by a costumed interpreter in the character of Wythe himself. Visit Colonial Williamsburg's website at https://www. colonialwilliamsburg.com and download its mobile app, the Colonial Williamsburg Explorer (which has coupons available only there). The Colonial Williamsburg Regional Visitor Center is located at 101-A Visitor Center Drive, Williamsburg, Virginia, 23185.

# THE UNIVERSITY OF VIRGINIA

*This institution will be based on the illimitable freedom of the human mind. For here we are not afraid to follow truth wherever it may lead, nor to tolerate any error so long as reason is left free to combat it.*

—*Thomas Jefferson to William Roscoe, December 27, 1820*

Many decades after he studied at the College of William & Mary and with his law tutor George Wythe in Williamsburg, Thomas Jefferson began

shaping up plans for a new college in Charlottesville that was to be called the Albemarle Academy, named for the county seat in which Monticello resided. In a letter from 1814, Jefferson wrote to an academic acquaintance, "I have long had under contemplation, & been collecting materials for the plan of a university in Virginia." The plan took another decade to come to fruition, with the first students not arriving for their studies until 1825, but knowing the heart and mind of Jefferson through his words and actions, it is easy to see why and how he was able to devote his retirement years to the creation of a brand-new college, an endeavor that he called "the Hobby of my old age." The institution, renamed the University of Virginia, was the first secular public college in the United States, and it sat in the valley below the little mountain in the distance where Monticello was built.

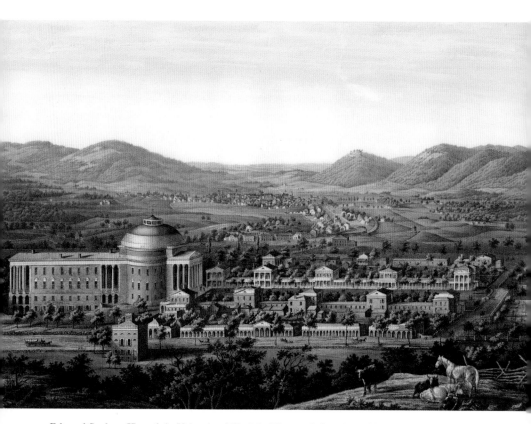

Edward Sachse, *View of the University of Virginia,* lithograph in colors, 21⅞ x 28⅞ inches, n.d. *Courtesy of the Yale University Art Gallery, Mabel Brady Garvan Collection, 1946.9.394.*

Although the Virginia state legislature didn't vote on funding for the college until 1819, Jefferson's planning began much earlier. Jefferson, of course, had attended the second-oldest institution of higher education in the colonies, but he also visited other places of learning such as Yale College, experiencing what is today called Old Campus with Ezra Stiles in 1784 when he stopped there on his way to Boston to leave for France. Stiles was the Yale College president, and a fellow patriot and intellectual, although unlike Jefferson, Stiles was also a theologian and a Congregationalist minister. Yale, like Harvard, was founded as a preparatory school for the elite and for religious ministry. The University of Virginia would look and feel very different from places like Yale, Harvard and the College of William & Mary because, as Jefferson stated in a letter from 1800, "we wish to establish in the upper & healthier country & more centrally for the state an University on a plan so broad & liberal & modern, as to be worth patronising with the public support, and be a temptation to the youth of other states to come, and drink of the cup of knolege." Visually and intellectually, Jefferson's new university was a different kind of place, and Jefferson's ideas were all over the plan—as were the hands, in a very real sense, of the enslaved people who helped build it.

Of the many tasks he engaged in on behalf of this start-up, Jefferson secured funding for the school, designed the campus and recruited the faculty. Further, he drew up the curriculum, which included the study of history, law, political economy, physics, ancient and modern languages, mathematics, botany, zoology, anatomy, medicine and government. He also engaged his friends (and fellow American presidents) James Monroe and James Madison to serve on the school's first board of visitors, and he himself was the first rector, or president. The site on which the University of Virginia was developed is familiar to anyone who drives through central Virginia today—rolling green hills with fertile valleys in between. Jefferson had walked, ridden a horse and driven a carriage across the lands for his whole life, and he knew instinctively how to take advantage of them for placement. Jefferson described the landscape in a letter to U.S. Capitol architect Benjamin Henry Latrobe (1764–1820) in 1817: "The site…is on a narrow ridge, declining from north to south, so as to give us a width between the 2 rows of pavilions of 200 feet only from East to West, and the gentle declivity [slope] of the ridge gives us three levels of 255 feet each from North to South, each about 3 feet lower than the one next above."

Here the word *pavilion* alerts us to the purpose of his "academical village" design, which would "afford the quiet retirement so friendly to study" that

*Above*: Eugene Daub, Rob
Firmin and Jonah Hendrickson,
*Thomas Jefferson Surveying the Site
that Would Become the University
of Virginia*, Darden School of
Business, University of Virginia,
2007. Gift of the class of 1974.
*Author's collection*.

*Right*: University of Virginia
marker, Virginia Department
of Historic Resources, 2003.
*Author's collection*.

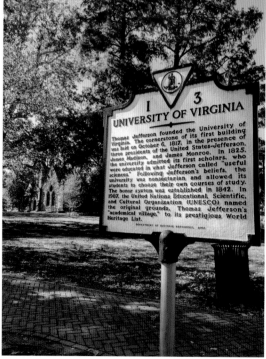

he found missing in places like the College of William & Mary and Yale College, which had buildings that were "large & common den[s] of noise, of filth & of fetid air." Instead, at UVA, two long rows of pavilions and rooms faced each other across a green lawn. There were ten pavilions (or structures) for professors, with two stories. On the first floors, professors met with their students and taught classes. On the second floors, professors lived with their families. In between the pavilions were student rooms, each with a fireplace and a door facing out onto the lawn. Today, students are given a rocking chair and a cord of firewood for their rooms, as well as a brass nameplate for their doors. Only fourth-year students can apply for one of these historic rooms. Only Edgar Allan Poe's room remains unused; he was a student here for one just one term in 1826, during the first year of the school's opening. Today, the Raven Society at the University of Virginia keeps his room open, and there is a historical marker nearby in the West Range, no. 13.

So that students would be learning all the time—including when walking the lawn—Jefferson designed each pavilion in a different architectural style. He wrote of this in 1817: "[N]ow what we wish is that these pavilions as they shew themselves above the dormitories, shall be models of taste & good

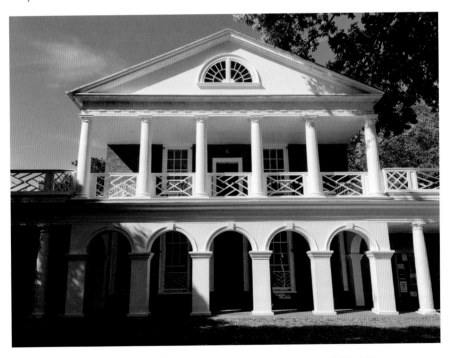

Example of Jefferson-designed pavilion facing the lawn, University of Virginia, Charlottesville. *Author's collection.*

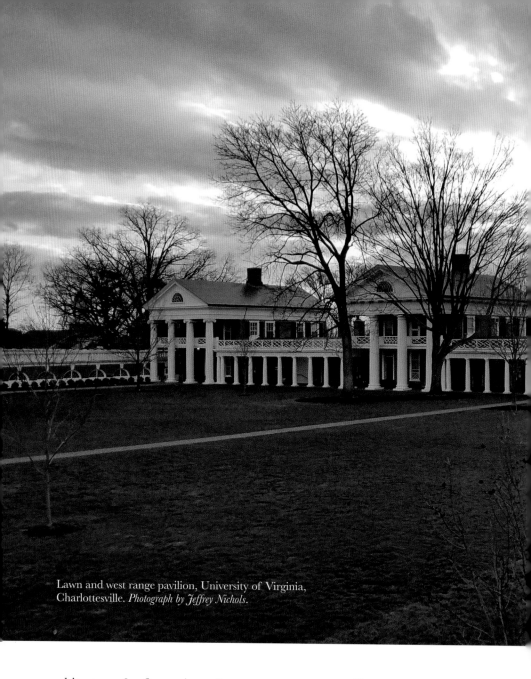

Lawn and west range pavilion, University of Virginia, Charlottesville. *Photograph by Jeffrey Nichols.*

architecture, & of a variety of appearance, no two alike, so as to serve as specimens for the Architectural Lectures." The architectural designs created throughout his whole life were based in Neoclassicism, but within that overarching architectural style there were variations coming from European sources: Greek, Etruscan, Italian and English. The point of having the two long rows (or arms embracing the students on the lawn) was to create a

sense of a village where learning was supported in every way. Both arms—or "ranges," in the UVA language—extend out from the central building of the village campus, which was the library, built in a centrally planned space called the Rotunda, much like the Pantheon in Rome.

Although he never made a visit to Rome, or the south of Italy, Jefferson took much inspiration from Italian history and culture—in the form of food,

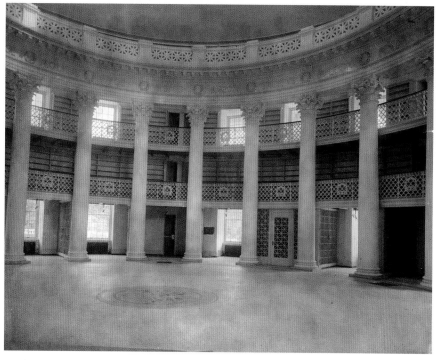

wine and, most of all, architecture. He acquired his knowledge about Roman architecture both from firsthand study in France and also from architectural pattern books, which enabled ideas and visual language to travel across oceans and time. The Pantheon (118–125 CE) is a building from Ancient Rome dedicated to "all the gods." Benjamin Henry Latrobe, the first professional architect in the United States, had suggested that Jefferson put the Rotunda at the end of the lawn to serve as a focal point. Jefferson turned the idea on its head by making the building the library—in other words, a secular space dedicated to knowledge and learning. This was in keeping with Enlightenment thought, which strove to banish, in Jefferson's thoughts about religion, "superstition." In a letter to a friend from Monticello in 1820, Jefferson wrote, "There exists indeed an opposition to it [the building of UVA] by the friends of William and Mary, which is not strong. The most restive is that of the priests of the different religious sects, who dread the advance of science as witches do the approach of day-light; and scowl on it the fatal harbinger announcing the subversion of the duperies on which they live." A recent rediscovery in the Rotunda has brought to life another facet of the building's original use: during renovations in the basement in 2016, a chemical hearth for a laboratory was found, which again points to the use of the building as a secular space for learning, far from the Christian religious worship that permeated American college campuses at the time. In 1890, the university finally built a nondenominational chapel on campus.

In 1819, Jefferson laid foundation for the University of Virginia, and when it was opened in 1825, he was eighty-one years old and had only one more year to live. Sixty-eight students studied under ten faculty members, and everyone lived on the Lawn. Although a dream of Jefferson's, UVA was built by enslaved men and women and by free African American laborers as well as whites. Slaves from area plantations were rented out by their owners for the work, and they literally crafted bricks out of red Virginia clay that would be used to build the pavilions and line the many passageways and garden walls. According to the university, one free man of color, Robert Battles,

*Opposite, top*: Student room on the lawn at the University of Virginia, Charlottesville. Note the rocking chair, which accompanies every room. During the winter months, wood is supplied for fireplaces. *Author's collection.*

*Opposite, bottom*: Interior, Rotunda, University of Virginia, Charlottesville. American architect Stanford White redesigned the interior of the Rotunda in 1895 after a fire. *Courtesy of the Library of Congress.*

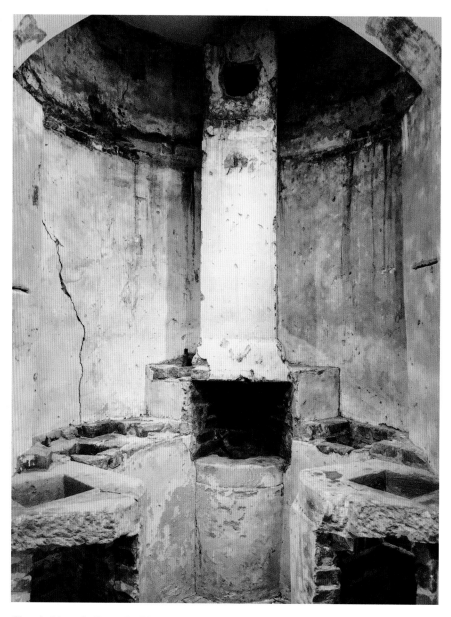

Chemical hearth, Rotunda, University of Virginia, Charlottesville. According to the university, this hearth "provided heat sources, ventilation and work stations for chemistry experiments" and dates from the opening of the Rotunda in 1825. *Author's collection.*

"hauled over 176,000 bricks and a few tons of sand to the university during a five-month stretch. For his Herculean efforts, he was paid $170." These bricks, now two hundred years old, attest to the great skill and work done by the enslaved, most of whom were not allowed to learn to read or write.

By this time in the United States, abolitionists and others had begun making their own plans for black colleges for free men and women of color. One such school proposal circulated in New Haven, Connecticut, where Yale College was located, in the 1830s. But like many other attempts at providing equality through education, the proposal for a black college was not accepted by the city. UVA's lawn, an actual terrace of earth dug by hand and a central feature of the campus; a similar feature at the mountaintop of Monticello that was leveled by hand; and the south lawn of Poplar Forest all demonstrate the huge role enslaved laborers had in carving spaces out of the Virginia Piedmont. As the university suggests in its special "Walking Tour of Enslaved African Americans at the University of Virginia," "between 1817 and 1865 the University relied on the labor of enslaved African Americans, whose presence was undeniably central to the building and functioning of the university." Thus, just as with the building of his personal homes, Jefferson—and much of the country—could not do the things they did without the labor of the enslaved. This fact will be formally recognized in a large way in 2018, the end of the university's bicentennial celebrations, when it opens the Memorial to the Enslaved Laborers, a $6 million installation behind the Rotunda.

The University of Virginia was the first secular college in the country, a fact noted when looking at the bronze statue of Jefferson placed in front of the Rotunda: Jefferson holds the document he crafted separating church and state, the Virginia Statute of Religious Freedom. The university was an important part of Jefferson's campaign to bring the Enlightenment to American education and, thus, society. As early as 1786, he had written that "the diffusion of knowledge among the people [is the] sure foundation… for the preservation of freedom and happiness." The cost of a public education, he thought, would be small compared to that of an uneducated populace: "The tax which will be paid for this purpose is not more than the thousandth part of what will be paid to kings, priests and nobles who will rise up among us if we leave the people in ignorance." The second rector of the university, James Madison, echoed these sentiments as well, writing in 1825, "The advancement and diffusion of knowledge…is the only guardian of true liberty."

The University of Virginia's Academical Village and Monticello were placed on UNESCO's World Heritage list in 1984—the only American university and historic house museum to have such status. The university is welcoming of visitors and tourists, and in 2017–19, the university celebrates its bicentennial. The cornerstone of Pavilion VII was laid by Thomas Jefferson in 1817, and he wrote the school's charter, which was adopted on January 25, 1819; the centennials of both are serving as the bookends to the university's celebrations. For information on the UVA bicentennial celebration, see the book *Mr. Jefferson's Telescope: A History of the University of Virginia in One Hundred Objects* by Brendan Wolfe or visit 100objects.lib.virginia. edu. To focus on African American contributions to UVA, take the walking tour by downloading the mobile app at http://slaveryvirginia.oncell.com or dial 434.326.4111 to follow instructions for the audio tour. To visit the UVA campus, you can start with a stop at the University Visitor Center, which is off campus (and also houses the university police department). The address is 2304 Ivy Road, Charlottesville, Virginia. Charlottesville also has a visitors' center, useful for exploring the larger area of shops, dining, wineries and historic sites beyond the historic campus and Monticello (see https://www. visitcharlottesville.org).

## JEFFERSON'S HOME SCHOOLING

While the University of Virginia was intended for the edification of the public, at home Jefferson was equally involved with continuing the education of his children and grandchildren and the children of his friends and acquaintances. Following the advice of his father and mentors such as George Wythe, Jefferson encouraged everyone in his orbit to keep to a strict schedule of reading and studying. He advocated for the acquisition of skills such as drawing, dancing and music for the women in his family. Jefferson's daughter Martha (called Patsy) and her husband and their ten children lived with Jefferson at Monticello from his retirement in 1809 until his death. Several of his grandchildren, such as Cornelia and Ellen, often accompanied Jefferson to Poplar Forest, where they kept up their reading and at-home education. He gave advice to his granddaughters constantly.

As a patriarchal figure, Jefferson also dispersed "canons of conduct" to young men and offered advice in letters to young men like Paul Aurelius Clay, the son of one of his Bedford County neighbors, Reverend Charles

Clay, who owned a plantation close to Poplar Forest. These rules were devised by Jefferson but often based in sayings that sound familiar, thus were likely in circulation. In his own words, Jefferson devised this canon for the purpose of "regulating his life by this code of practice [which may] bring pleasure and profit to his life." Jefferson's "Ten Rules" were written in a letter to Charles Clay from Poplar Forest, July 12, 1817. He wrote a similar list to Thomas Jefferson Smith from Monticello on February 21, 1825. Putting them together, they are as follows:

- *Never put off tomorrow what you can do today.*
- *Never trouble another for what you can do yourself.*
- *Never spend money before you have earned it.*
- *Never buy what you don't want because it is cheap; it will be dear to you.*
- *Pride costs more than hunger, thirst and cold.*
- *We seldom repent of having eaten too little.*
- *Nothing is troublesome that we do willingly.*
- *How much pain the evils cost us that never happened.*
- *Take things always by the smooth handle.*
- *When angry, count to ten before you speak; if very angry, count a hundred.*

These canons of conduct may have been mottoes he heard from others, such as Benjamin Franklin, but they are Americanisms that are passed down through generations. Even Mark Twain (1835–1910), the most important American writer of the Gilded Age, loved such sayings, following on Jefferson with his own twist: "When angry, count four; when very angry, swear." Before he became Mark Twain, Samuel Langhorne Clemens (whose father was born in Campbell County, Virginia, close to Thomas Jefferson's Poplar Forest) wrote under the pen name of Thomas Jefferson Snodgrass for a short time.

# JEFFERSON'S DEMOCRACY

## COUNTY COURTHOUSES, STATE CAPITALS AND WASHINGTON, D.C.

Thomas Jefferson's great love for words, ideas and books originated with his father, Peter Jefferson. Although unschooled in a formal sense, Peter was a huge reader, and so, too, was his household. A logical role for young men in the eighteenth century with good reading and writing skills might be that of a clergyman or teacher, but the most coveted position was that of a lawyer. Becoming a lawyer was, in Jefferson's time, a position of respectability, service and social connections across large swaths of the public. Jefferson himself recognized this, and after his liberal arts undergraduate education and law studies in Williamsburg, Jefferson practiced law in central Virginia, in counties near and around his birthplace. The seven years of law practice provided him with his first forays into the workings of local government as a representative of the oldest elected legislature in the new world, a position enlarged considerably when he became a member of the Virginia House of Burgesses, a member of the Second Continental Congress, governor of Virginia, secretary of state, vice president and finally president of the United States.

That Jefferson was so intrinsically bound to Virginia in his views of an ideal Republican government is clear. He was prepared to contribute to, and helped shape, the evolution of the royal colony into a commonwealth. This was done by remaking the Virginia Constitution, a document formed by "consent of the people and guided by the rule of law." Philosophically, Jefferson wanted a society bound by the rational but free thinking of the Enlightenment, where government, education and society were given equal roles to play in the

creation of an agrarian-based but educated populace and where the best of European and American thinking could be applied to problems facing the growth of the young country. In his work for Virginia, Jefferson attempted to remake laws on crime, inheritance (although he personally benefited from primogeniture, he wanted to abolish it), religion, education and the slave trade. Jefferson's ideals for democratic governance were not perfect, were often not put into place and sometimes earned him political enemies, but his impact at the local, state and national levels is demonstrable:

- *member of the House of Burgesses, 1768*
- *delegate from Virginia to the Second Continental Congress, Philadelphia, 1775*
- *writes Declaration of Independence, 1776 at age thirty-three*
- *elected to the Virginia House of Delegates; appointed to revise Virginia laws*
- *drafts the Virginia Statute for Religious Freedom, passed by General Assembly, 1786*
- *governor of Virginia, two terms, 1779–81*
- *trade minister to France and minister to France, 1784–89*
- *secretary of state in George Washington's cabinet, 1790*
- *vice president to John Adams, 1797–1801*
- *president, two terms, 1801–9*

That Jefferson was the only American statesman who was an architect means that we can read his ideals and ambitions in the architecture he created for government, a situation wholly unique to him and Virginia.

## CAPITOL BUILDING, WILLIAMSBURG (RE-CREATED IN THE 1930s, COLONIAL WILLIAMSBURG FOUNDATION)

Williamsburg, in York County, is a place to find Thomas Jefferson. Even though its streets and many buildings are a re-creation of the eighteenth century, now, after almost one hundred years of tourism, study and interpretation, Williamsburg has a special place in the hearts of many Americans and international visitors (the fact that Bill Barker and Kurt Smith perform in the persona of Thomas Jefferson weekly doesn't hurt either). The original capitol building in Williamsburg was in existence from 1701 to

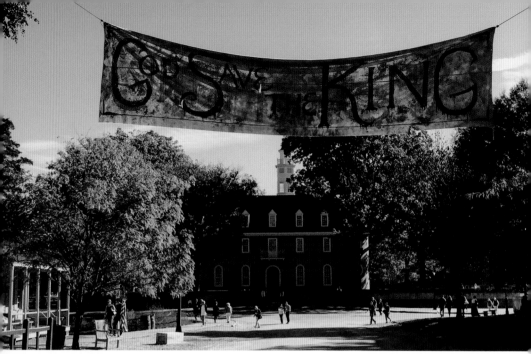

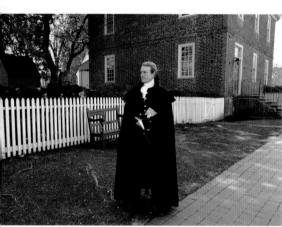

*Above*: "God Save the King" banner over Duke of Gloucester Street in front of the capitol building (reconstructed in the 1930s), Colonial Williamsburg. *Author's collection.*

*Left*: Kurt Smith as Thomas Jefferson, Colonial Williamsburg. *Courtesy of Susan McCall Smith.*

1747, when it burned; Jefferson would therefore not have known the original building. A second building of a different style was built that looked like a large mansion house with a double-story portico on its façade (much like Poplar Forest would have later). Jefferson called the capitol building "light and airy" and "the most pleasing piece of architecture we have." As noted in a previous chapter, Jefferson lived in Williamsburg twice during his lifetime: from 1760 to 1762 as a student at William & Mary and then intermittently as a student with George Wythe from 1762 to 1766. Jefferson returned to Williamsburg in 1779, serving as the governor of Virginia. During the years of the American Revolution (1775–83), the capital was moved inland from

Williamsburg to Richmond, which was thought to be safer—away from marauding seaborne attacks. In 1776, when Jefferson was governor of Virginia, he drafted a bill that set in motion his role in the creation of a new state capitol building for Richmond, in the "Bill for the Removal of the Seat of Government of Virginia," dated November 11, 1776.

## GOVERNOR'S PALACE (RECONSTRUCTED 1934, COLONIAL WILLIAMSBURG FOUNDATION)

The Governor's Palace at Colonial Williamsburg was built specifically as the governor's residence in 1722 after a lengthy construction history. This two-story Georgian-style structure (with Flemish bond) of eight rooms served both Patrick Henry and Thomas Jefferson during their tenures as Virginia governors in the war years. Henry lived here during his tenure from 1776 to 1779, with Jefferson following from 1779 until 1780, when he left for Richmond and the new seat of state government. The "palace," called so with irony due perhaps to its extravagant decorations (there is a unicorn statue outside), was a center of social life in the capital of Williamsburg and gave Jefferson a taste of what was in store for him in the future at Monticello: a constant influx of people and goods, moving through the palace and demanding attention of a political, social or practical nature.

An unusual archaeological discovery potentially associated with Thomas Jefferson here in Williamsburg is a polished bone handle, possibly a toothbrush. Found by archaeologists in 1988, the bone handle is inscribed, "Thos. Jefferson." Because toothbrushes were used mainly by the elite and because bone usually disintegrates in acidic soil, finding this artifact was an unusual discovery. As Marley R. Brown III, the director of archaeological research for Colonial Williamsburg at the time, noted, "Such discoveries [of personal inscribed objects] are rare indeed…one of the most remarkable discoveries yet made in over 50 years of digging in the Historic Area of Williamsburg." The bone handle is very curved, which is unlike most toothbrushes, either today or in the past, and thus archaeologists today are more suspicious as to its intended use, as well as whether it did in fact belong to the same Thomas Jefferson. Although no others of the same name living in Williamsburg at the time have been identified, there later was a hotel named for Thomas Jefferson located in this area, and the object may have been part of a toiletry kit offered to guests.

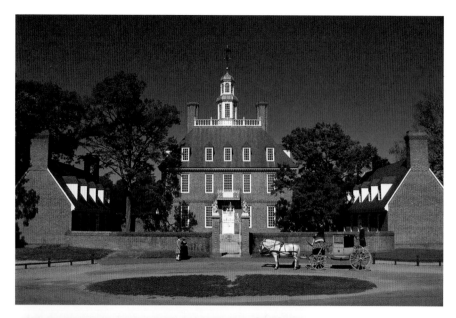

*Above*: Governor's Palace (reconstructed in the 1930s), Colonial Williamsburg. *Courtesy of the Colonial Williamsburg Foundation.*

*Left*: Bone handle inscribed "Thos. Jefferson." *Courtesy of the Colonial Williamsburg Foundation.*

After Jefferson moved the capital to Richmond (and designed a new statehouse in the city for its functions), the Governor's Palace was empty for a year before the Continental army used it for a hospital. American soldiers killed in the Battle of Yorktown died here and were buried in the adjacent garden. Then, on December 22, 1781, the brick building caught fire and burned to the ground. Colonial Williamsburg eventually rebuilt the Governor's Palace and Capitol Building on site, anchoring the historic area.

## THE STATE CAPITOL OF VIRGINIA, RICHMOND (1788)

*But how is a taste in this beautiful art to be formed in our countrymen,
unless we available ourselves of every occasion when public buildings are
to be erected, of presenting to them models for their study and imitation?*

—*Thomas Jefferson to James Madison, 1785*

Due to Thomas Jefferson's influence, Richmond became the state capital of Virginia in 1780. Not only did Jefferson move the colonial capital from Williamsburg to Richmond, but he also designed the building that is still in use today. From France, where he was ambassador, Jefferson drafted letters and drawings for the new capitol building—even having a plaster model made that was shipped to Richmond. For the five years prior, after Jefferson moved the government to Richmond, members of the state legislature met in an old tobacco warehouse while waiting for the capitol building to be completed. The foundation stone was laid for the new structure on August 18, 1785.

Architectural historian and museum director Fiske Kimball called the Virginia State Capitol the "first monument of the Classical Revival in America." If one thinks about what was to follow—all the classically inspired buildings from the East Coast to the West Coast and everywhere in between, in cities large and small—you understand just how important Jefferson's architecture in Richmond was to the young country. The building was the first government structure completed after the Revolutionary War and thus did model—as Jefferson suggested to Madison in 1785—what American government architecture should look like. Kimball found that Jefferson had been directly influenced by the Maison Carrée in Nîmes, France, in his design for Richmond. Jefferson knew about buildings like the Maison Carrée, a Roman temple from the first century CE, from books filled with architectural renderings. Jefferson called the structure the "most perfect and precious remain of antiquity in existence." Jefferson's building was designed to house the functions of state government and thus needed to be larger than the sacred functions of an ancient temple. The Maison Carrée was used as inspiration, and a strict adherence to proportion was followed, although the size was much larger. The capitol was planned as 134 feet long, 70 feet wide and 45 feet high. The Ionic order was chosen by Jefferson for the façade portico, and an entablature runs the whole length of the building on the exterior.

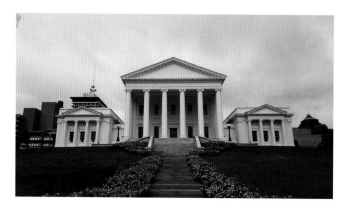

State capitol building designed by Thomas Jefferson, with wings added in the early twentieth century, Richmond, Virginia. *Photograph by Jeffrey Nichols.*

Pierre-Émile-Joseph Pécarrère (French, 1816–1904), the Maison Carrée in Nîmes (ancient Roman temple), 1851, salted paper print from a waxed paper negative, 19 × 25.6 cm (7½ × 10 1/16 in.). *The J. Paul Getty Museum, Los Angeles.*

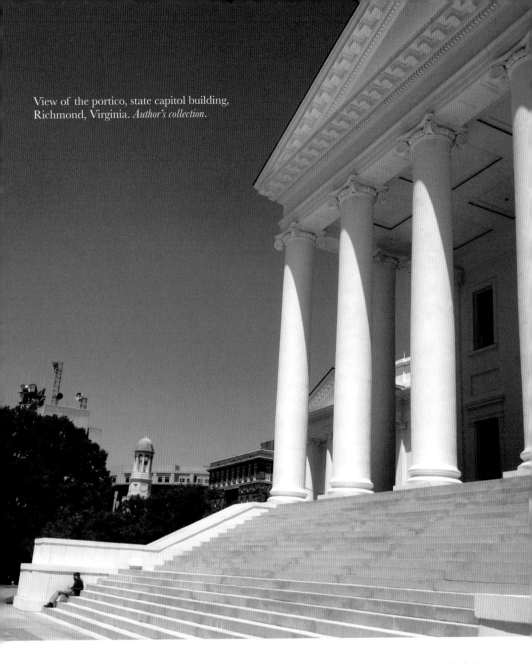

View of the portico, state capitol building, Richmond, Virginia. *Author's collection.*

Jefferson's devotion to classicism never waned, and because he died in 1826, he would not live to see the development of the next great phase of American architecture, an era of eclectic and hybrid styles offered by the worldwide purview of the Victorian era. It's fairly easy to imagine Thomas Jefferson cringing at the various styles—Queen Anne, Tudor, Gothic Revival, Italianate, Moorish and more—in use in the decades after his death, sometimes even mixed together in one building. For Jefferson, the

creation of a new country, with a new government based on Enlightenment principles of self-determination, could use only one style of architecture, classicism, which was invented by the ancient Greeks and adapted by the ancient Romans, the first people in the history of the world to have a version of a democratic style of government. In his work in Richmond, Jefferson sought a partnership with Charles-Louis Clèrisseau, a French architect who had studied the Maison Carrée in person. Once finished, the structure garnered the attention of visitors from far and wide. "This building is, beyond comparison, the finest, the most noble, and the greatest in all America," wrote one visitor from France in 1796.

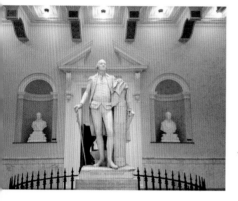

Jefferson hired Edward Voss of Culpeper County to lay 1,500 bricks in Richmond, and he sent to Europe for "any stone which may be wanted." The roof was covered with lead, which was thought better by Jefferson than copper or tiles. In the center of the building was placed a statue of George Washington carved in white Carrara marble from Italy—the same marble and the same quarry from which Michelangelo carved such masterpieces as *David*. Jefferson and Benjamin Franklin, who together commissioned the statue from French sculptor Jean-Antoine Houdon, recognized the symbolism in material. Further, when Jefferson placed Washington at the center of the building, he was playing off the ancient world's use of figural statues to provide the purpose of the building—ancient Greek and

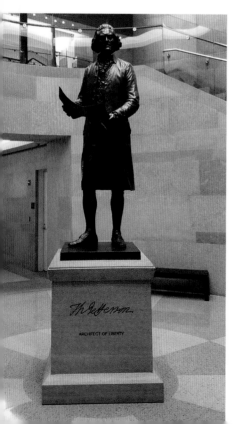

*Top*: Jean-Antoine Houdon, statue of George Washington inside the Rotunda, state capitol building, Richmond, Virginia. *Photograph by Jeffrey Nichols.*

*Bottom*: Ivan Schwartz and StudioEIS with Jiwoong Cheh, Thomas Jefferson, Architect of Liberty, 2012, bronze, 8 ft., visitors' center, state capitol building, Richmond, Virginia. *Photograph by Jeffrey Nichols.*

Romans put statues in their temples for worshiping. Virginians and other early Americans put statues in their buildings not for worship but to give legitimacy to the new government and its founders. Houdon completed a life mask of Washington and his life-size statue. He would go on to sculpt many of the Founding Fathers, including Jefferson himself. Houdon's statue of Washington in the Rotunda of the capitol building is surrounded by busts of seven other Virginia-born presidents: Thomas Jefferson, James Madison, James Monroe, William Henry Harrison, John Tyler, Zachary Taylor and Woodrow Wilson. A Roman Pantheon for Richmond, Virginia.

The state capitol building in Richmond is open for tours and has a new visitors' center complete with a bronze monument of a forty-two-year-old Thomas Jefferson holding the architectural plans for the capitol. Inside the capitol building proper, you can also see a full-length portrait of Jefferson by George Catlin in the Jefferson Room, as well as the original plaster model commissioned by Jefferson and crafted by Jean-Pierre Fouquet. The state capitol on Capitol Square is a National Historic Landmark, open to the public for free one-hour guided tours Monday through Saturday, 9:00 a.m. to 5:00 p.m. and Sunday, 1:00 p.m. to 5:00 p.m. Visitors enter at the main entrance at Tenth and Bank Streets, Richmond, Virginia, 23219. Note that the complex contains Meriwether's Café, a gift shop and a Virginia Travel Information Center. A self-guided tour of the state capitol building is also available.

# WASHINGTON, D.C.

Even before his own tenure began in Washington, D.C., the new capital city of the new country, Thomas Jefferson began influencing the design there for a monumental mall or green space with classical buildings surrounding it, which he thought most appropriate for the seat of government. Jefferson actually drew up plans for Washington, D.C., and included the forms he loved the most: domes, columns, villas and pediments. The design by Pierre L'Enfant was chosen, not Jefferson's, although both contained similar design elements. Finally, as president, Jefferson could and did provide advice for building projects such as the U.S. Capitol and the White House. Constantly tinkering with architecture when living in the White House himself (1801–9), Jefferson added wings, just as he had at Monticello and Poplar Forest, in addition to gardens.

## COUNTY COURTHOUSES

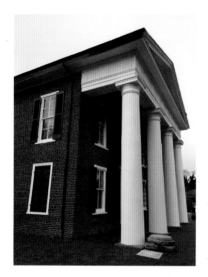

Buckingham County Courthouse, Virginia. *Author's collection.*

In his retirement from government service, Thomas Jefferson continued to serve local governments through the design of county courthouses in Virginia, including in Buckingham County and Charlotte County in the 1820s. The Charlotte County Courthouse is the only known Jefferson design still standing, for although the heavy pedimented building in Buckingham County looks to be from Jefferson, the structure was the victim of fire in 1869 and the current building is considered a loose approximation of Jefferson's original design (archaeological excavations have found some of the foundations underneath). It is likely that Jefferson furnished plans to many other courthouses that have not survived, including in Botetourt County. The Fincastle County Courthouse is said to be in the "Jefferson lineage" of courthouse designs, as are courthouses in Lunenburg and Mecklenburg.

For Charles Brownell, an architectural historian, "among courthouses, which traditionally were Virginia's most important civic buildings, the Old Dominion preserves a cycle of buildings that ever-so-tangibly embed Jeffersonian thinking in solid masonry." Further, "these buildings," according to Brownell, "succeeded in his wish to reform Virginia architecture." Jefferson's ideas for architecture were likely spread about the state by the workmen who carried his ideas as they worked on other projects. The Buckingham County Courthouse is worth a visit for Jefferson fans, as there is an interpretive panel on site and an installation of markers indicating where Jefferson's original building once stood.

# JEFFERSON'S HOME

## MONTICELLO AND MULBERRY ROW

*I am as happy no where else & in no other society & all my wishes end, where I hope my days will end, at Monticello.*
*—Thomas Jefferson to Dr. George Gilmer, August 12, 1787, from Paris*

One aspect of the mythology about Thomas Jefferson is focused on a man on a mountaintop who lives a privileged life among verdant fields and gardens, surrounded by his books, family and friends in a house he designed himself. Americans took to this story so completely that in 1938, Jefferson and his home, Monticello, were put on currency—and remain on the American nickel eighty years later. The myth of the man on the mountaintop wasn't destroyed, but it was altered forever in the last quarter of the twentieth century when documentation as to Jefferson's relationship with Sally Hemings became irrefutable and was accepted by the Thomas Jefferson Foundation Inc., the not-for-profit organization that has managed and interpreted the house and grounds since 1923. Wrapped up in this mythology was special reverence for a man often referred to, even today, as "Mr. Jefferson." Monticello continues to draw visitors, more than 430,000 every year, but now a fuller story, a better story, is told. It is better because it is more truthful to the past than the mythology served up as history for far too long.

Because Monticello was purposefully designed by Jefferson as his primary residence, and because he clearly loved being there, it is no less valuable to know how the house and grounds *worked* than it is to appreciate its beauty

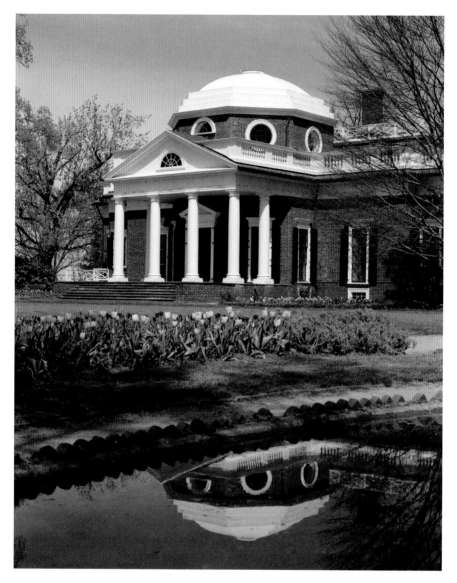

Rear façade of Monticello. *Courtesy of the Library of Congress.*

and unique placement on the mountaintop and how it came to be. It is in the workings of the house and grounds that we come to know Monticello and its inhabitants, black and white, all of whom lived and worked together on the "little mountain" (which Monticello translates to in Italian) for more than three decades under the watchful eye and constant rebuilding of Thomas

Jefferson. In other words, Monticello is often thought of as a house, but it was the center of a working plantation, of which the house was only one part of an extensive system that spread over thousands of acres in central Virginia. As Gayle Jessup White recently said at the "Universities, Slavery, Public Memory & the Built Landscape" symposium held at the University of Virginia in October 2017 to celebrate the university's 200th anniversary, "Monticello is a microcosm of what happened in the United States as a whole.…Monticello was a black place—everything that happened at Monticello happened *because* of black people." As the community engagement officer at Monticello and a Jefferson descendant, White not only works to ensure that Monticello continues to tell the whole story of the site, but beyond this, and most importantly, she also wants people of color to feel comfortable and welcome at Monticello. As she restated and the audience of the symposium knowingly responded, "African-American history is American history."

Researching and interpreting more of the story of Monticello through the vantage point of the enslaved men, women and children who lived and worked on the mountaintop contributes significantly to the iconic status the house has today. Monticello is the only American house listed on the UNESCO World Heritage list—a survey of the greatest architectural and historical structures around the globe, including the Taj Mahal and the Tower of London. Other American houses, such as George Washington's Mount Vernon and the White House, aren't listed, which suggests the value of the site not only to Americans but also to world development and world history. The fact that the Thomas Jefferson Foundation Inc. has worked diligently in the first decades of the twenty-first century to emphasize the enslaved story has transformed the historic house and grounds into a different model, from one where a single male and his achievements are celebrated to a site of balanced storytelling, inclusive of all the people who contributed to the workings of the house and the lifestyle that allowed Jefferson to accomplish tremendous things that affected the world. Jefferson was able to do so through the system into which he was born, raised and continued in his adult life, a system based on the institution of slavery, which Jefferson himself referred to as "having the wolf by the ear." Humans are attached to long-held beliefs about beloved, historic heroes, none more so for Virginians than Thomas Jefferson. To think that changing such a long-standing narrative is easy is false. But this work goes on—with more archaeology, more oral histories and more publications on material culture, students of history, no matter their age, move ever closer to the truth.

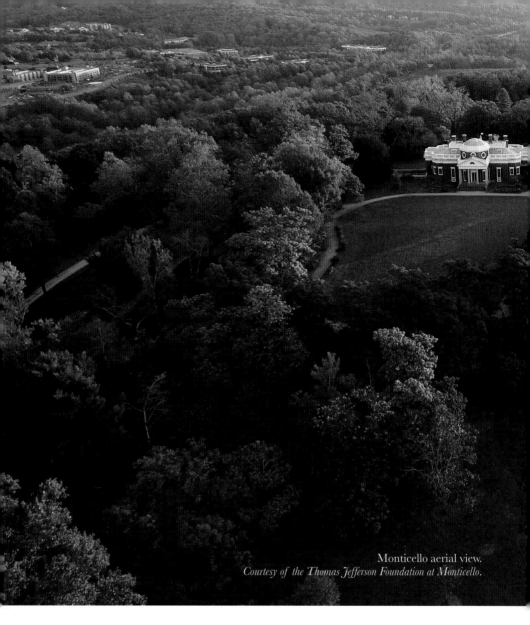

Monticello aerial view.
*Courtesy of the Thomas Jefferson Foundation at Monticello.*

But World Heritage status, of course, wasn't on Thomas Jefferson's mind as a fourteen-year-old young man whose father had just died. As noted earlier, when Peter Jefferson died in 1757, Thomas—his eldest son—had the choice of three properties that he would inherit upon turning twenty-one. Jefferson kept Shadwell, the family home, and in addition chose Monticello and Montalto—here began building his adult life, centered on the things he loved and dreamed of whenever public service removed him from Virginia and from home. Many decades later, in 1809, when finally in retirement from public life, Jefferson wrote that he wanted "to indulge the evening

of my life with what have been the passions of every portion of it, books, science, my farms, my family and friends. To these every hour of the day is now devoted."

He does not ever say it (or write it, in one of the tens of thousands of surviving letters), but at Monticello, Jefferson also fathered a second family with Sally Hemings and kept almost one hundred people enslaved to work his quarter farm sites. Monticello was always a work in progress, from the house itself to the fruits and vegetables grown to the families he watched over. That's why, in some ways, seeing Monticello on the American nickel

is a falsehood—it gives us the sense that the house was built and stayed the same for all of Jefferson's long life (and there are no people shown there—only the façade of the house). Nothing could be further from the truth. Jefferson's vision for Monticello changed as he traveled more widely and viewed ancient and contemporary buildings first hand. He called Monticello "My Essay in Architecture" because, like an essay, it could be rewritten. A brief overview/timeline of the building program at Monticello—from 1764 to 1823—looks something like this:

*1764: Thomas Jefferson inherits Shadwell, Monticello and Montalto from his father's estate, including both enslaved people and land.*

*1768: Jefferson begins construction of Monticello; enslaved laborers level the mountaintop, which is 867 feet high.*

*1770: Shadwell burns; Monticello's South Pavilion is completed; Jefferson and his family live in the south chamber while Main House is being built; first child, Martha, is born here in 1772.*

*1771: Construction begins on Monticello; during the ensuing years of rebuilding and construction, much of it is done by enslaved men trained by hired craftsmen.*

*1778: The brickwork of Monticello is finished.*

*1784: Jefferson is in France as commissioner and minister; construction on Monticello halts.*

*1786: Jefferson travels in England with John Adams, visiting historic English estates, including Stowe, Blenheim and Woburn. But most important were Chiswick House, Lord Burlington's Palladian villa outside London, Hampton Court, Stowe and Hagley Hall.*

*1790: Jefferson returns from Paris to Monticello; will soon begin extensive remodeling. In his own words, "I was violently smitten with the L'Hôtel de Salm, and used to go to the Tuileries almost daily to look at it." From France, Jefferson brings ideas for domes, skylights, narrow stairs and bed alcoves. The interior of Monticello was also influenced by Jefferson's travels to England during the summer of 1786.*

*Left*: Statue of Thomas Jefferson looking at L'Hôtel de Salm, Paris, France. *Author's collection.*

*Right*: Detail, Thomas Jefferson holding the plan for Monticello, Paris, France. *Author's collection.*

*1800: Dome is constructed at Monticello.*

*1801–3: North and South Terraces are built over wing of offices (also called "dependencies").*

*1805: Interior painting of Monticello begins; floors are installed.*

*1806: Construction on Poplar Forest, his retreat in Bedford County, begins.*

*1809: Monticello is largely complete, as is the exterior of Poplar Forest; Jefferson begins retirement.*

*1823: Doric columns are installed on West Portico of Monticello.*

The design of the house, its particular architectural style, remains one of the most alluring parts of Monticello. Derived from multiple European sources, the red brick house with painted wooden shutters and decorated

with classical motifs (in the capitals of the columns and the entablatures) is actually an amalgamation of the American landscape and European architectural designs going back hundreds, even thousands, of years. As discussed previously, the earliest structures in the Virginia colony were built in a Tudor or a hybrid Baroque/Neoclassical style exemplified in the work of Sir Christopher Wren, befitting their seventeenth-century origins in England. Later, Thomas Jefferson himself was behind the American push for a purer Neoclassicism in architecture, which was used in the state capitol building in Richmond and in numerous county courthouses around central Virginia. But for his home, Thomas Jefferson sought something slightly different—he would not turn away from Neoclassicism, but he needed a form of building appropriate to housing his family and he was not interested in the kind of buildings others lived in, such as George Washington's Mount Vernon or James Madison's Montpelier, both of which were large, traditional Georgian- or Federal-style mansions. He found a different source for his homes—both Monticello and Poplar Forest—from a pattern book created by an Italian architect named Andrea Palladio. Palladio's *I Quattro Libri dell'Architectura* (*The Four Books of Architecture*) was first published in 1570, and its influence on Jefferson was profound. Many villas—often rural retreats or summer homes—were built around what is today northern Italy, espousing Palladio's Neoclassical villa designs. Both England and America exported these villa designs to their own countries, and it's this heritage, in conjunction with the Piedmont landscape, that would shape Jefferson's version of Neoclassicism.

Palladio was a stonecutter who became the most famous architect of the High or Post-Renaissance world. His architecture inspired English architects Christopher Wren and Inigo Jones, who built the greatest examples of classical buildings in England, such as St. Paul's Cathedral. Palladian architecture made its next stop in the New World, thanks most directly to Thomas Jefferson, who adapted his views to the geography, climate and soil of Virginia. Thus, granite of England becomes red brick in Virginia, and wooden shutters are liberally used to keep out the southern sun, a problem England does not have. Green or black paint on the shutters keeps the wood from rotting and ties the house to the green landscape in which it sits. The characteristics of classicism are a devotion to proportion and the use of columns corresponding to the four styles, called "orders" of architecture from the ancient world (Tuscan, Doric, Ionic and Corinthian from the Etruscans and Greeks and revived by the Romans). Jefferson's columns are buff colored to replicate stone, although they are brick covered with stucco—an adaption of the sort for which Jefferson was well known.

Much like the ideas and words of the documents he drafted for the new republic, Jefferson's creativity came from his ability to modify, customize and combine earlier concepts. Thus, he also imported elements of decoration from the ancient world in the use of heavy pediments and entablatures. For this, Jefferson drew inspiration from classical buildings such as the Roman temple of Portunus, also called the Temple of Fortuna Virilis. All of the interior entablatures around the ceilings of Monticello have ornamental plaster surfaces, called "friezes," that travel across the width of the room. Ancient Roman decoration consists of ox skulls, swags, urns and putti that reference ancient pagan practices but also refer to war, the bountiful earth and children. These things are to be seen at Poplar Forest and the University of Virginia.

The Monticello that is interpreted today—the Monticello of Phase III, the last phase before Jefferson's death—is characterized by all of these things, although discovering original paint colors and the arrangement of furniture and material goods such as paintings and prints on the walls, and books on the shelves, continues to be refined even to this day—the most recent example is the re-creation of Jefferson's so-called Sanctum Sanctorum, which Monticello unveiled to the public in 2017. From the

Cabinet called the "Sanctum Sanctorum," part of Jefferson's private suite. *Courtesy of the Thomas Jefferson Foundation at Monticello. Photograph by Walter Smalling.*

Compass under the portico roof, Monticello. *Author's collection.*

outside, the house looks deceivingly small: there are forty-three rooms in total—thirty-three in the main house, four in the pavilion and six under the South Terrace, where the major work of the house happened. During Jefferson's lifetime, visitors were allowed into the public rooms consisting of the Entrance Hall, the Parlor, the Dining Room and the Tea Room. Jefferson's dedication to welcoming the public into his house is demonstrated by the fact that the Entrance Hall had twenty-eight chairs placed around the perimeter of the room to accommodate guests. Visitors step onto the portico and above their heads see a hand-painted compass inserted into the ceiling above—details like this abound at Monticello relating to science, the weather, artwork, maps and, in the case of the Entrance Hall, where guests were greeted, artifacts relating to Native American and natural history, some of which Jefferson received from the Lewis and Clark Corps of Discovery journey and from items he likely collected himself from the Virginia landscape. Some of the many things to be seen here include antlers (moose, deer, elk and American bighorn sheep) and mastodon fossils found in Kentucky. This room is an American presentation of Enlightenment thought if there ever was one!

Privacy was thus a challenge for Jefferson, and he dealt with it by creating features in his house meant to offer separation from the hordes of visitors. As noted, he kept his private rooms, the Sanctum Sanctorum, to himself; these were on the east side of the main house. And finally, he built Poplar Forest—three days' ride away from Monticello—to get away from the hustle and bustle of his primary home, as noted by Jefferson interpreter Bill Barker, a place where he said, "I may go to read, to write, but most importantly, a place where I may think." The Sanctum Sanctorum at Monticello has the following rooms: Book Room, Greenhouse, Cabinet and Bedroom. Only Jefferson and the enslaved people who served him most closely used these spaces. In addition to the problem of dealing with the constant stream of visitors, and in order to mitigate the amount of time Jefferson spent with the enslaved people laboring to keep his home running, Jefferson adapted features to the house that minimized contact. For example, a hidden rope pulley system in the dining room allowed bottles of wine to be brought up

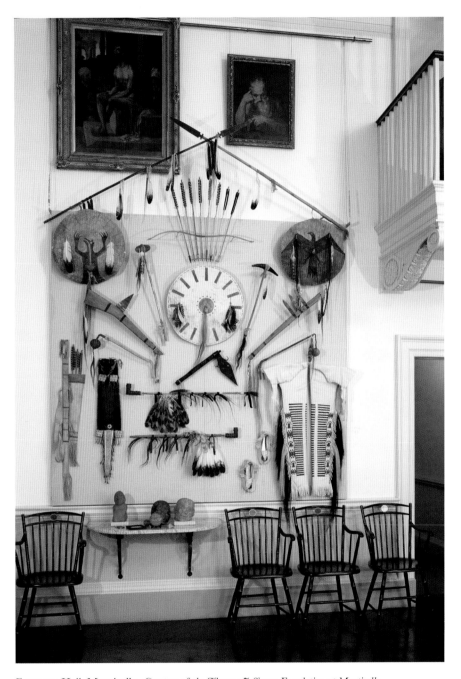

Entrance Hall, Monticello. *Courtesy of the Thomas Jefferson Foundation at Monticello.*

and down without the need to engage directly with people, and he also used dumbwaiters—a stacked wooden tray on four legs—in the dining room at both Monticello and Poplar Forest to keep warm food ready for serving and allowing for conversation in private. A bell system at both Monticello and Poplar Forest allowed the Jefferson family and guests to call their enslaved servants when needed.

This is a very similar idea to the wing of offices, which were hidden from view. The two wings of offices, which are workrooms built along a long axis extending like arms from the main house, allowed a walking terrace to be built on the roof. These structures were half buried in the earth to hide them from view; thus, when approaching the house, even today as a twenty-first-century visitor, the wings cannot be seen from the façade view. This, for many scholars, suggests that Jefferson wanted to hide the wings of offices because enslaved people worked in these rough spaces—the kitchen, laundry and storage rooms are located here, all of which are steamy or dirty and none of which contained the refined classical decorations of the main house. Still in the process of recovery is the fact that Sally Hemings lived in one of these rooms in the wing of offices, which was only excavated in

*Above*: Bedroom, Monticello. *Courtesy of the Thomas Jefferson Foundation at Monticello.*

*Opposite*: Terrace, wing of offices, Monticello. *Author's collection.*

*Left*: Passageway, wing of offices, Monticello. *Author's collection*.

*Below*: Kitchen, Monticello. *Author's collection*.

late 2017. The small space that may have once served as her bedroom/ private space had been turned into a bathroom for visitors in the 1950s. Her room in the house, although in the wing of offices, is suggestive of the intimate relationship between Jefferson and Hemings. Hemings family members were the only enslaved people given freedom upon his death. The other enslaved families of Mulberry Row, Poplar Forest and Jefferson's other quarter farm sites—many of whom were born and lived their whole lives at Monticello—were all sold.

## MULBERRY ROW

*Mulberry Row was the dynamic, industrial hub of Jefferson's 5,000-acre agricultural enterprise. As the principal plantation street, it was the center of work and domestic life for dozens of people—free whites, free blacks, indentured servants, and enslaved people. It was populated by more than 20 dwellings, workshops, and storehouses between 1770 and the sale of Monticello in 1831.*

*—Thomas Jefferson Foundation at Monticello website*

There were 130 enslaved men, women and children at any one time at Monticello—more than 600 over the course of Jefferson's lifetime. In order to house the enslaved community and provide more work spaces for things such as making barrels (called a "cooper") or crafting nails for use in building projects, a row of small structures was built along one edge of the mountaintop, lower on the slope, from which everyone could travel up to the house for work or farther down the slope to work in the vegetable and fruit gardens or beyond in the fields of wheat and tobacco. This streetscape of cabins for work and home for the enslaved of Monticello is called Mulberry Row. Up until recently, the main house was separated from Mulberry Row by boxwoods, which had been planted in the early twentieth century. The original slave cabins are long gone, but with the removal of the boxwood hedges in 2016 and the rebuilding of two cabins, the relationship between Monticello (the house) and Mulberry Row is clear. Archaeologists have uncovered more than seventy-five thousand artifacts from Mulberry Row— information that has opened layers of understanding today considered equal in importance to the story of the main house.

*Above*: Re-created enslaved cabin on Mulberry Row, Monticello. *Author's collection.*

*Left*: Costumed interpreters on Mulberry Row, Monticello. *Author's collection.*

Neoclassical chair made in the Monticello joinery, circa 1790–1815. *Courtesy of the Colonial Williamsburg Foundation.*

The lives of many of the enslaved at Monticello are coming into clearer focus. For example, Burwell Colbert, grandson of Elizabeth (Betty) Hemings, began working in the nailery on Mulberry Row at Monticello at age ten and later trained as a painter and glazier. In Jefferson's retirement, Colbert became Jefferson's personal manservant and butler, managing other enslaved housemaids, waiters and porters. Although Jefferson paid him twenty dollars annually, Colbert was not granted his freedom until Jefferson died in 1826—he along with only four other Hemingses. Another Hemmings, John, born in 1776 to Elizabeth (Betty) Hemings, became the head joiner at Monticello after James Dinsmore retired in 1809. Dinsmore, an Irish American craftsman, trained Hemmings—in this way Jefferson could have a skilled craftsman whom he did not have to pay. Hemmings built the small log cabins on Mulberry Row, which Monticello is currently rebuilding today, as well as architectural woodwork in both Monticello and Poplar Forest. Hemmings could craft anything out of wood, including doors, desks, chairs and refined molding. Jefferson would later write, "The whole commerce between master and slave is a perpetual exercise of the most boisterous passions, the most unremitting despotism on the one part, and degrading submissions on the other. Our children see this, and learn to imitate it; for man is an imitative animal." Although he knew full well his role in its continuation, he never broke from the practice. One young woman from Charlottesville commented on this history recently, saying, "The Master sitting on top of Monticello….[T]his is Charlottesville…this is what we deal with every day as African-Americans."

Getting to Monticello and the mountaintop wasn't easy in Jefferson's time. Today, you drive the curving roads in an automobile, but in Jefferson's time, you had to cross the Rivanna River to reach the base of the mountain and then ascend up East Road on horseback or carriage, although the steep ascent made some folks walk instead of ride. One such visitor in 1815 commented, "The ascent of this steep, savage hill, was as pensive and slow as Satan's ascent to Paradise." Your journey will hopefully not be as

dramatic. The house and grounds are open year-round for tours, which include general daily tours as well as specialized tours behind the scenes, seasonal tours, the garden tour, the Slavery at Monticello tour or the sunset pass, where visitors can experience the setting sun from the mountaintop. To visit Monticello today, start by familiarizing yourself with the organization's expansive website at www.monticello.org, where you'll find multiple options for touring—including hiring your own guide for a private tour.

# JEFFERSON'S AGRICULTURE AND HORTICULTURE

## GARDENS, ORCHARDS, VINEYARDS AND FIELDS

*No occupation is so delightful to me as the culture of the earth & no culture comparable to that of the garden.*
—*Thomas Jefferson to Charles Willson Peale, 1811*

First foodie. America's first oenophile (wine connoisseur). Experimenter. Old man but young gardener. Gentleman farmer.

From the beginning of Thomas Jefferson's tenure on the Monticello mountaintop in the early 1770s, agriculture and horticulture were primary occupations and pleasures in his life and work. On his more than ten thousand acres of land in total—plantations large and small, quarter farms and creeks, with odd extras such as a limestone quarry and a natural bridge—Jefferson grew much, experimented with more and thoroughly identified himself as a "cultivator of the earth" in the belief that "agriculture…is our wisest pursuit, because it will in the end contribute the most to real wealth, good morals, & happiness." Jefferson owned land in Albemarle, Bedford and Campbell Counties, as well as in urban locations such as one lot in Richmond and four lots in Beverly. Some land he inherited from his father, some from his father-in-law and some he purchased. On these lands, Jefferson's enslaved laborers grew cash crops such as tobacco, wheat and rye and more than 300 varieties of vegetables and 170 fruits for his own use and to sell. Here also Jefferson experimented with new techniques for seeds and crops, recording his findings in his "Garden Book" and other journals. William Peden wrote that "from his

Vegetable garden at Monticello: one-thousand-foot-long terraced garden divided into twenty-four plots. Jefferson organized the garden by the part of the plant to be harvested: "fruits" (tomatoes), "roots" (beets) or "leaves" (lettuce). *Author's collection.*

mountain top at Monticello, overlooking the green and golden farmlands of Albemarle, he had peered into the vast laboratory of nature and had scrutinized like a lover the phenomena of the weather."

When friends traveled, Jefferson was sure to send a message, asking for samples of seeds. When he traveled, such as his time in France, Jefferson wrote to friends such as Nicholas Lewis asking him to send watermelon, cantaloupe and sweet potato seeds to share with Europeans. While living in Paris for five years, Jefferson noted that "I cultivate in my own garden here Indian corn for the use of my table, to eat green in our manner." Ever the Virginian, even in the midst of pre-Revolutionary France, with its luxurious lifestyle, Jefferson ate green corn and wore plain clothes. In return for sharing American agricultural heritage, Jefferson's French friends gave him grapevines and other plants. When he returned to Virginia in 1789, in his more than ten boxes of material goods he had purchased while abroad—books, ceramics, furniture and kitchen utensils—he also stored seeds and

plants in containers. Friends asked him for plantings and seeds, including the Comtesse de Tessé, the Marquis de Lafayette's aunt, who requested a long list of native plants from Jefferson. In 1790, Jefferson responded to her by having the requested plants collected and prepared for travel. The containers bound for the Comtesse's estate near Versailles included tulip poplars, magnolias, mountain laurels, red cedars, sassafras, dogwoods, persimmons, oaks and shrubs. In return, Madame de Tessé later sent Jefferson a "golden-rain tree" (*Koelreuteria paniculata* from east Asia) for Monticello, one of the earliest planted in America. Monticello had flower and vegetable gardens but also a small greenhouse, adjacent to Jefferson's bookroom, where he grew fragrant orange trees and may have kept pet mockingbirds.

Jefferson's granddaughters Anne and Ellen Randolph were frequent gardening companions and correspondents. Before his much-anticipated retirement from public service in February 1809, Jefferson wrote to Anne and told her that he would return to Monticello in three weeks, and "then we shall properly be devoted to the garden." Two years later, in 1811, he wrote to Anne again describing the floral display at Monticello—"the flowers come forth like the belles of the day, have their short reign of beauty and splendor and retire…the hyacinths and tulips are off the stage, the Irises are giving place to the Belladonnas, as these will to the Tuberoses, etc." Early American gardens had flowers such as Sweet William (*Dianthis barbatus*), which was one of Jefferson's favorite ornamental flowers, as well as Johnny-Jump-Up (*Viola tricolor*), which looks like a pansy, with purple, yellow and white, and which Jefferson planted at Shadwell on April 1, 1767. Also liked by Jefferson were Nasturtiums (*Tropaeolum majus*). One flower is even named for Jefferson: the Twinleaf (*Jeffersonia diphylla*) blooms only once a year and can be found at Poplar Forest.

For more on Jefferson and horticulture, you can visit Tufton Farm, which is the home of the Thomas Jefferson Center for Historic Plants. Originally one of Jefferson's quarter farms attached to Monticello, today the center studies historic plant varieties of interest to Jefferson (irises are a specialty), offers community workshops and sponsors an open house three times a year. Heritage seed packets and plants from the Thomas Jefferson Center for Historic Plants can be purchased in the gift shop at Monticello and Poplar Forest. For more information, see https://www.monticello.org/site/house-and-gardens/thomas-jefferson-center-historic-plants.

Gardens, orchards, vineyards and farms were testing grounds to determine which flowers, trees, vegetables and fruits would grow most successfully on his land, for Virginia and for the new country too. Jefferson grew apples

Twinleaf (*Jeffersonia diphylla*) at Thomas Jefferson's Poplar Forest. *Photo by Jeffrey Nichols.*

View from Tufton Farm and Thomas Jefferson Center for Historic Plants, Charlottesville, Virginia. *Author's collection.*

Collection of heirloom seed packets, Thomas Jefferson Center for Historic Plants, Charlottesville, Virginia. *Author's collection.*

(Newtown Pippin was a favorite), cherries and pears, as well as olives, almonds, pomegranates and figs. Later, he learned to grow apricots, pears, plums and nectarines. New vegetables Jefferson tried in his garden were tomatoes, rutabagas, artichokes, eggplants, broccoli, cauliflower, lima beans, peanuts and sea kale. He loved English peas, planting as many as fifteen types per year, as well as many bean varieties.

The importance of agriculture as a republican enterprise, and the bounty of the land of the United States was reinforced inside the house as well. At Monticello, for example, Jefferson hung still-life paintings of fruit and vegetables in the dining room that reference the purpose of the room but also reinforce his political persuasion: in this new democratic country, people could partake of the bounty of the land. Jefferson's interest in agriculture and horticulture meant that the foods served at his table were a combination of indigenous American fruits and vegetables such as corn and imported and exotic treats such as olive oil and Parmesan cheese.

Jefferson's interests in agriculture and horticulture experimentation spilled over into his plans for the University of Virginia, as well. As described earlier, the college grounds were created in the form of two ranges of pavilions surrounding a green lawn. But behind these structures were small gardens, hidden from view behind high brick walls. These garden spaces, which you can visit today, were utilitarian work spaces for cultivation, animal pens and smokehouses. Today, they are filled with trees, flowers and benches—and one space contains the Merton Spire, a fifteenth-century sandstone steeple from Merton College Chapel at Oxford University, gifted to UVA in 1927, connecting Jefferson's vision yet again to the model of higher education in England. You can find the steeple with some effort, in a garden behind Pavilion VI of the east range. Likely seen in English gardens when he traveled

there with John Adams in 1786, the brick walls designed by Jefferson were both practical and beautiful: serpentine walls required only one course of bricks, but their curving shape helps to create solidity. Like much else in Jefferson's life, these walls were made of bricks crafted of the Virginia soil by enslaved laborers.

Jefferson wished that the everyday use of the gardens, for food, medicines and dyes, would also translate into academic study through the creation of a botanical garden, as well as by hiring a professional botanist to teach. When he died, these plans were abandoned but were more recently taken up at Morven Farm, a 2,913-acre property once owned by Jefferson himself and now part of the University of Virginia Foundation. Morven has a kitchen garden where there are "hands-on learning opportunities to study food production cycles, design sustainable agriculture technologies, and develop a better understanding of the social, environmental, and economic implications of daily food choices." Close to Morven Farm are Monticello, James Monroe's Highland, Michie Tavern and numerous vineyards open to the public; on site is also the Flowerdew Hundred Collection of AmerIndian, English and African American artifacts unearthed at the Flowerdew Hundred on the James River south of Richmond (see www.flowerdew.org).

Jefferson's experiments and innovations regarding agriculture are seen in his attempt—over the course of thirty years—in trying to introduce grapes to the Virginia landscape for winemaking so that the New World could rival, and surpass, the Old World. This was both a private and public mission; Jefferson considered wine to be "a necessary of life," but once the new country was established, the project took on greater meaning. In 1807, he tried twenty-four different varieties of European grapes, as well as North American grape varieties such as fox grape (*V. labrusca*) and the southern muscadine (*V. rotundifolia*), known as scuppernong. Today, two hundred years after Jefferson's grape-growing experiments, Virginia is one of the top five wine producing states in the country. The production and demand for Virginia wine has grown exponentially since the turn of the twenty-

*Opposite, top*: Raphaelle Peale (American, 1774–1825), *Still Life: Basket of Peaches*, 1816, oil on wood, 13¾ x 19⅝ in. (34.9 x 49.8 cm.); framed (d): 2 1/16 in. (5.2 cm.); framed (h): 18½ in. (47 cm.); framed (w): 24⅞ in. (63.2 cm.). *Estate of James W. Fosburgh, BA 1933, MA 1935, Yale University Art Gallery, 1979.13.1.*

*Opposite, bottom*: James Peale (American, 1749–1831), *Still Life: Balsam Apple and Vegetables*, oil on canvas, circa 1820s, 20¼ x 26½ in. *Maria DeWitt Jesup Fund, Metropolitan Museum of Art, 39.52.*

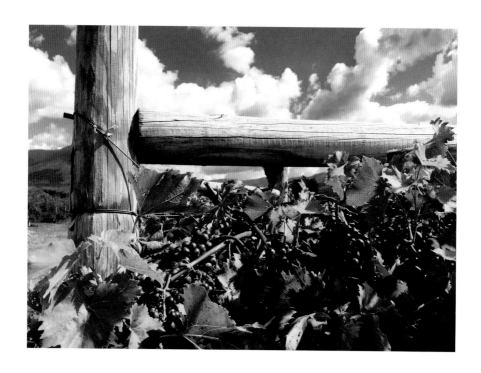

*Above*: Serpentine wall, University of Virginia, Charlottesville, Virginia. *Author's collection.*

*Opposite, top*: Grapes enjoying the Virginia sunshine. *Author's collection.*

*Opposite, bottom*: Vineyard in Nelson County with a view of the Blue Ridge Mountains. *Author's collection.*

first century. In 2004, Virginia had 80 wineries; today there are more than 250! Most Virginia wineries produce the same wines that are produced in Europe: Cabernet Sauvignon, Merlot, Chardonnay and Cabernet Franc. One white grape, Viognier, because of its thick skin and its adaptability to warm weather, grows well in central Virginia. One native grape, Norton, produces intense red wines comparable to many European reds. Some of Virginia's most popular wines are Viognier, Meritage, Cabernet Franc and Petit Verdot. There are one thousand wine festivals in Virginia every year. In other words, viticulture—the science, production and study of grapes—has become much more than Thomas Jefferson could have envisioned more than two hundred years ago. Virginia makes world-class wine and reaps the benefits of an agricultural bounty that feeds into cultural tourism.

There are several ways to get into the enjoyment of viticulture in central Virginia. Wine and heritage trails, as well as state-sponsored

Winemaking apparatus can be seen through the paneled glass floors at Blenheim Vineyards. *Courtesy Blenheim Vineyards.*

viticulture areas such as the Monticello American Viticulture Area, all produce maps and digital sources to lay out driving tours and places to visit for tastings. The Monticello AVA includes Albemarle and surrounding counties, encompassing more than half of Virginia's wine country, and contains more than 1,200 acres of vineyards. Vineyards in the Monticello AVA benefit from a natural east-southeast exposure and mild spring temperatures. Varieties special to Monticello AVA include Cabernet Franc, Norton and Viognier. For more information on the Monticello AVA and the Monticello Wine Trail, including the Taste of Monticello Wine Trail Festival held every April, see monticellowinetrail.com. To take a broader view and connect Thomas Jefferson's two homes, Monticello and Poplar Forest, with a drive stopping at vineyards along the way, visit the Jefferson Heritage Trail at www.jhtva.com.

There are three wineries of interest to Thomas Jefferson enthusiasts. The first, Jefferson Vineyards, is located on the grounds where Jefferson and Filippo Mazzei from Tuscany first began their experiments at a farm called Colle, where the "American wine revolution" began. In a letter to George Washington on January 27, 1779, Mazzei wrote, "In my opinion, when the country is populated in proportion to its extent, the best wine in the world will be made here....I do not believe nature is so favorable to growing vines in any country as this." Jefferson had given Mazzei almost two hundred acres of his property to start, which Mazzei increased. Together, Jefferson and Mazzei also shared a love for liberty, and Mazzei was given credit by the United States Congress in 1994 for the phrase "All men are created equal," used by Jefferson in the Declaration of Independence. Visit the Jefferson Vineyards website at jeffersonvineyards.com.

*Left*: Jefferson Vineyards. *Author's collection.*

*Right*: Reproduction of Houdon bust of Jefferson, Jefferson Vineyards. *Author's collection.*

Not far from Jefferson Vineyards is Blenheim, a historic farm with Revolutionary connections that became a successful vineyard in 2000, when musician and philanthropist Dave Matthews purchased the property (Matthews' Bama Foundation supports not-for-profit organizations throughout the Albemarle County). It was Blenheim where Thomas Jefferson and his new bride, Martha, are said to have "rested and warmed themselves" after their coach stalled nearby during a snowstorm on their way to Monticello in January 1772. Later, the Jeffersons continued on to Monticello on horses borrowed from Edward Carter, the original landowner and the man from whom Filippo Mazzei purchased land to expand his vineyard. Blenheim became the site of a Revolutionary War prison for officers, and Jefferson and Martha became frequent visitors—these acts may have saved Monticello from being burned later by the British. Blenheim was sold in 1840 and the house burned a few years later, but there are nineteenth-century buildings on site and sometimes tours of the history are given. The property is in the National Register of Historic Places and is a registered Virginia Historical Landmark. Visit the Blenheim Vineyards website for more information at blenheimvineyards.com.

Barboursville ruins, Barboursville Vineyards. *Author's collection.*

Finally, a little farther afield and straddling both Albemarle County and Orange County is Barboursville Vineyards, another site where viticulture and history have come together. Barboursville was the home of James Barbour, one-time governor of Virginia, for whom Jefferson designed a house with classical features, such as a portico, columns and an octagon in the center of the building for use as a drawing room. The house was completed in 1821 but burned in 1884. The ruins of the house became a feature of the Barboursville Vineyards when Gianni Zonin—heir to a winemaking business dating to 1821 in the Veneto in Italy—began a winery here. And in another little Thomas Jefferson touch, Barboursville Vineyards' signature wine is now called "Octagon" (see www.bbvwine.com).

# JEFFERSON'S RURAL RETREAT AND PLANTATION

## POPLAR FOREST

*I write to you from a place 90 miles from Monticello…which I visit three or four times a year, & stay from a fortnight to a month at a time. I have fixed myself comfortably, keep some books here, bring others occasionally, am in the solitude of a hermit and am quite at leisure to attend to my absent friends.*
*—Thomas Jefferson to Benjamin Rush, August 17, 1811*

Very much a well-kept secret, Thomas Jefferson's Poplar Forest, a perfect octagon villa with a view of the Blue Ridge Mountains, is the last significant green space in a heavily developed suburban development. The small house is a jewel of architecture, a perfected vision of proportion and elegance built from a lifetime of study.

Thomas Jefferson's granddaughter Ellen Coolidge wrote about Monticello, "[A]lmost every day for at least eight months of the year, [it] brought its contingent of guests." The house called Poplar Forest was built by Thomas Jefferson as a refuge from the visitors who streamed to Monticello, as noted by Ellen, who often stayed at the retreat with her grandfather. Jefferson had an octagon retreat house built on land he had owned for decades, which did not come to him through his father, Peter Jefferson, but through his father-in-law. Named for a forest of tulip poplar trees, which Jefferson called the "Juno of our groves," Poplar Forest plantation belonged to John Wayles, the father of Martha Wayles Skelton, whom Jefferson married on January 1, 1772. John Wayles died the following year, leaving his daughter the lands, farms and the enslaved people

who lived and worked at Poplar Forest, all of which passed to Thomas Jefferson. These almost 4,800 acres were important to Jefferson's acreage in the Piedmont, contributing to his total agricultural output, especially of tobacco and wheat, much like the quarter farms around Monticello.

Before Jefferson began building the octagon-shaped retreat house in 1806, he rarely visited the plantation, keeping a resident overseer on site to manage the farms and people. But the plantation became a refuge for Jefferson and his family in 1781, when they fled Richmond and then Monticello, with Banastre Tarleton and the British army in pursuit (for more on this story, see *The Road to Yorktown: Jefferson, Lafayette and the British Invasion of Virginia* by John Maas, The History Press, 2015). While living in the overseer's house over the course of two months, Jefferson began writing out answers to the questions posed by François Barbé-Marbois—which would become *Notes on the State of Virginia*, his only full-length published book.

While finishing out his presidency (1801–9), Jefferson began constructing one of the first octagonal homes in America, but work continued on the interior until 1823, just three years before his death. Since he was not on site while most of the house was under construction, Jefferson wrote copious letters, directing his paid craftsmen in their work (who would then direct the enslaved laborers), down to the smallest details. John Hemmings, an enslaved carpenter, worked on Poplar Forest for ten years—creating almost all of the joinery and woodwork. He could read and write and thus conversed with Jefferson directly. One of his doors remains in the house today, a survivor of the 1845 fire that gutted all of the Jefferson-era woodwork. Jefferson, of course, already had two decades of experience in the building and rebuilding of Monticello, and much of the architectural aesthetic and construction method is similar between the two houses. But at Poplar Forest, Jefferson was able to refine his vision of the perfect domestic refuge, which he thought, as he wrote in 1812, was "the best dwelling house in the state, except that of Monticello, perhaps preferable to that, as proportioned to the faculties of a private citizen." Eventually, Jefferson came to Poplar Forest three or four times per year, seasonally, for stays of two weeks to several months.

When the restoration of Poplar Forest began in 1990, the comprehensive documentation on the construction of the house—including Jefferson's letters—enabled the not-for-profit organization the Corporation for Jefferson's Poplar Forest to make the unique decision to restore the house using the same techniques, the same materials and even the same historical sequence of Jefferson's long initial construction and finishing. The

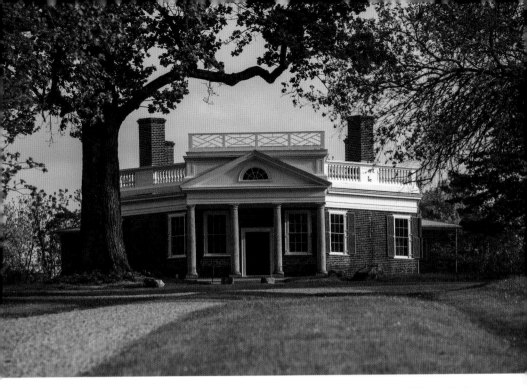

Thomas Jefferson's Poplar Forest, 1806–9, Forest, Virginia. *Courtesy of Thomas Jefferson's Poplar Forest. Photograph by John Henley.*

organization has won major preservation awards for this ongoing restoration work. Thirty years later, the work continues.

The octagonal design of the house has six single rooms on one level over a raised, unfinished basement, which contains the wine cellar, a recessed floor in the earth. The basement was also the sleeping space for Burwell Colbert, Jefferson's personal enslaved servant. Upstairs (there is a short staircase on both sides of the house) in the center of the octagon is the dining room, a perfect cube of twenty by twenty by twenty feet, with a skylight above—again, one of the first for an American home (Monticello has thirteen skylights with double panes of glass to prevent leaks). The North and South Pavilions at Monticello are cubes (twelve feet, seven inches each), which is an idea replicated in the dining room of Poplar Forest. Of the more than 300,000 artifacts excavated by archaeologists at Poplar Forest, some of the most thoroughly studied come from the dining room. Multiple pieces of blue transfer-printed ceramics have been found, with a design called the Oxford and Cambridge College pattern. This Ridgway pattern of scenes of campus life at England's oldest universities is set into octagon shapes—a perfect complement to the octagon house and the octagon-edged three-part

Bill Barker as Thomas Jefferson at Poplar Forest, 2015. *Author's collection.*

dining room table. As Jack Gary, director of archaeology and historic landscapes at Thomas Jefferson's Poplar Forest, suggests in a recent essay, "The patterns we see in the transfer-printed ceramic assemblage contain many cues that tie into Jefferson's personal interests, such as architecture, public education, and landscape design."

Attached to the front (north) and back (south) face of Poplar Forest are Neoclassical porches called porticoes, with columns made of molded bricks plastered with lime mortar to replicate the appearance of stone. The main floor comprises 1,927 square feet of living space—small in size compared to Monticello's 11,000 square feet—but this indicates the quality of life and living Jefferson wanted to do here, which was simplified and provided intimacy with his family. Like Monticello, the gardens and landscape of Poplar Forest were not supposed to be cut off from the living spaces but rather extensions of them, so triple-sash windows and doors opened onto the south portico and a terrace, which was the roof of the wing of offices. In 1817, Jefferson painted a picture for daughter Martha about her daughters, Ellen and Cornelia, who often accompanied Jefferson to Poplar Forest, writing in 1817 that "about twilight of the evening, we sally out with the owls and bats, and take our evening exercise on the terras."

Some of the enslaved families at Poplar Forest, such as the Hubbards, were related to the Hemingses of Monticello. This included Phil Hubbard, an enslaved laborer who had a great impact on the landscape of Poplar Forest. In June 1807, Jefferson directed mason Hugh Chisholm to "engage the negroes to dig and remove the earth south of the house....I would gladly pay [them] for it. But it is only with their own free will and undertaking to do it in their own time. The digging and removing is worth a bit a cubic yard." Hubbard took on that work, and a year later, in September 1808, he was still working at it. Jefferson wrote to Chisholmm "I wish to know what progress Phil has made in the digging, and would have him Continue at it under your direction." Today, Poplar Forest presents Shakespeare's plays, the musical

*Above*: Dining room. *Courtesy of Thomas Jefferson's Poplar Forest. Photograph by Michelline Hall.*

*Middle*: Blue transferware-print plate with the Oxford and Cambridge College pattern, circa early nineteenth century. *Courtesy Thomas Jefferson's Poplar Forest. Photograph by Michelline Hall.*

*Bottom*: Theater Printing House pattern, Oxford and Cambridge College print series (1813–30), Ridgway. Found in the topsoil of the wing of offices during excavations and the West Allee. The pattern depicts the Sheldonian Theatre, designed by Christopher Wren in the 1660s and currently used for matriculation, lectures and recently added dramatic productions. The building was constructed with a press house in it for the Oxford University Press, but it was moved to the Clarendon Building in 1713, which is the other building. *Courtesy Thomas Jefferson's Poplar Forest.*

Artistic interpretation of Phil Hubbard, enslaved laborer at Poplar Forest, digging out the south lawn. Katie McBride, 2016. *Courtesy Thomas Jefferson's Poplar Forest.*

*1776* and other activities on this expansive lawn—the very ground that Phil Hubbard dug out more than two hundred years ago.

When Jefferson, often accompanied by his granddaughters, came down to Poplar Forest, they took a route through what is today Appomattox County, crossing the James River and creeks and staying in taverns (similar to Michie Tavern). The following itinerary was created and written by Lucia Stanton for the Thomas Jefferson Foundation at Monticello and is based on Jefferson's travels in the spring of 1816. Stanton pulled information from various sources to create this day-by-day itinerary, which captures the pace and style of travel of Thomas Jefferson in the years of his retirement from public service and of the Virginia landscape, pockets of which are still to be found when traveling back roads and country lanes, especially in Nelson, Buckingham and Appomattox Counties:

### DAY 1

*"Set out for Poplar Forest." On his seventy-third birthday, probably shortly after recording the first spring planting of his favorite "grey" snap bean,*

*Jefferson stepped into his carriage and gave Israel and Gill Gillette the signal to depart. As not a drop of rain fell between April 6 and May 11, the landau's tops may have been down, and its occupant may have looked as George Flower found him at Poplar Forest later in the year: "His dress, in color and form, was quaint and old-fashioned, plain and neat—a dark pepper-and-salt coat, cut in the old quaker fashion, with a single row of large metal buttons, knee-breeches, gray-worsted stockings, shoes fastened by large metal buckles."*

*MILE 10.7*
*Here the landau crossed Carter's Bridge over the Hardware River. Less than a mile before the bridge the ringing of a bell could be heard through the sounds of trotting horses and jangling harness. Jefferson recorded mileages with an odometer, which had been given him in 1807 by its maker, James Clark of Powhatan County. He mounted it on the wheel of his carriage and particularly extolled two of its special features: it divided the mile decimally into dimes and cents and chimed like a clock every ten miles. Jefferson found "great satisfaction in having miles announced by the bell as by milestones on the road."*

*MILE 22.7*
*Here Jefferson reached the James River at Warren and spent the night, as he did the first night of almost every journey to Poplar Forest, with the first citizen of Warren, Wilson Cary Nicholas. This great friend had served as governor of Virginia, his daughter had recently married Jefferson's grandson Thomas Jefferson Randolph, and his bankruptcy during the Panic of 1819 would deliver the "coup de grâce" to Jefferson's already crumbling fortunes.*

**DAY 2**
*"Warren. vales .50 ferrge & watermen 4.D." Jefferson first began using the English term "vales" in 1786, when he left gratuities for the servants in his London hotel. After tipping Nicholas's servants, he crossed the James River by ferry.*

*MILE 32.05*
*By mid-morning, the landau reached the gate of Gibson's tavern, two miles south of the little Buckingham County community of Glenmore, but did not turn in. As his hermit's solitude at Poplar Forest was not intended to*

The James River near Scottsville, Virginia. *Author's collection.*

*be entirely unrelieved, Jefferson may have had two female companions to shelter from the cool winds blowing over the open landau. Granddaughter Virginia reported that "in his journeys to Bedford, he always took two of us along with him. I often now think of those journeys, generally made in good weather, and with every attention to our comfort. Early in the morning, he was sure to have some additional wrapping to put over the shoulders of each of us, generally a large cape off from one of his cloaks, and if the weather was cold we were wrapped in his furs." A number of letters identify the fur of choice, a wolfskin pelisse given to Jefferson in 1798 by General Thaddeus Kosciuszko. Jefferson suffered a great deal from the cold in his later years and this pelisse accompanied him often in his travels. During one December trip, he had "(thanks to my pelisse) felt no more sensation of cold on the road than if I had been in a warm bed."*

## MILE 39.05
*Having travelled on what are now county routes 627 and 602, the equipage arrived at the Raleigh tavern, kept by Daniel Guerrant, just west*

Hatton Ferry, the last pole ferry operating in Virginia, on the James River, 2017. *Author's collection.*

*of Buckingham Courthouse. Halfway through this long day on the road, one might have expected the travellers to take some refreshment there, but it is evident from the memorandum books that Jefferson stopped at inns during the day only for breakfast or to feed his horses. He was no exception to the rule observed by one of his Monticello visitors, Mrs. William Thornton, that "Virginians do not stop more than is absolutely necessary at taverns in travelling." Jefferson himself said that "cold victuals on the road" were "better than any thing which any of the country taverns will give you." One of his granddaughters described their roadside picnics: "Our cold dinner was always put up by his own hands; a pleasant spot by the road-side chosen to eat it, and he was the carver and helped us to our cold fowl and ham, and mixed the wine and water to drink with it."*

MILE 56.09
*The carriage arrived at the tavern kept by Major Henry Flood just northwest of Old Appomattox Courthouse in what was then Buckingham County. They had finally reached a major thoroughfare, "the great main*

road" from *New London* to *Richmond, now state route 24. According to granddaughter Ellen, "we always stopped at the same simple country inns, where the country-people were as much pleased to see the 'Squire,' as they always called Mr. Jefferson, as they could have been to meet their own best friends. They set out for him the best they had, gave him the nicest room, and seemed to hail his passage as an event most interesting to themselves."* Flood's tavern was Jefferson's favorite second-night lodging, and it was probably the location, called "Ford's" in Henry Randall's account, of an encounter that entered the fund of popular anecdote about the travelling ex-president. At this tavern, Jefferson engaged in a conversation with a local parson, first on the subject of mechanics. The parson found his interlocutor so knowledgeable he thought he was an engineer, and after the next topic, agriculture, had been exhausted, he was certain he was talking to a very great farmer. Finally their discussion of religion convinced the parson that his companion was another clergyman, "but he confessed that he could not discover to what particular persuasion he leaned."

## DAY 3
*"H. Flood's lodgg. &c. 4.17."*

### MILE 66.59
*"Hunter's breakfast 2.08."* Robert Hunter's tavern was on what is now state route 24 near Concord on the present Campbell-Appomattox county line. In the eyes of his granddaughters, even on the third day on the road, Jefferson was the ideal travelling companion: "His cheerful conversation, so agreeable and instructive, his singing as we journeyed along, made the time pass pleasantly, even travelling through the solitudes of Buckingham and Campbell counties over indifferent roads."

### MILE 78.34
The travellers reached Campbell Courthouse (now Rustburg). On Jefferson's return journey in May, the landau's axle broke somewhere in this vicinity. Jefferson's enslaved butler Burwell Colbert always accompanied him on the journeys to Poplar Forest and rode behind the carriage on Jefferson's saddle horse. When the axle broke, Colbert probably rode to the nearest settlement for assistance, while Jefferson remained behind, entertaining his granddaughters if they accompanied him, or reading if alone. He always carried a book in his pocket on his travels and, according to his granddaughters, that book was usually a tiny Latin edition of the lives of

*distinguished men by Roman historian Cornelius Nepos. Jefferson confirms this by mentioning "a little Cornelius Nepos I had in my pocket" on a journey the previous fall.*

*MILE 85.94*
*The carriage forded Flat Creek*

*MILE 93*
*After three long days of travel, Jefferson arrived at his destination. Burwell Colbert and Israel Gillette exchanged their roles as travelling attendant and postilion* [a person who rides the leading left-hand horse of a team or pair drawing a coach or carriage, especially when there is no coachman] *for those of butler and assistant waiter. The Randolph granddaughters turned to their books, drawings, and embroidery. And Jefferson settled in to a routine governed only by his own wishes and the rotation of the earth. He casually dispensed with the Copernican system in one tranquil report from his retreat: "The sun, moon and stars move here so much like what they do at Monticello...that they afford nothing new for observation." Each day offered unobstructed enjoyment of solitary indoor*

Entrance road to Thomas Jefferson's Poplar Forest. *Courtesy Thomas Jefferson's Poplar Forest. Photograph by John Henley.*

Curtilage fence, Thomas Jefferson's Poplar Forest. *Courtesy Thomas Jefferson's Poplar Forest. Photograph by John Henley.*

View from entrance to Poplar Forest with bronze statue of Thomas Jefferson in dining room. *Courtesy Thomas Jefferson's Poplar Forest.*

*occupation in the morning, exercise on horseback in the middle of the day, and the company of family members at the appointed hour for society at the end of the day. At Poplar Forest he passed his time "in a tranquility and retirement much adapted to my age and indolence."*

Poplar Forest was a perfected and personal vision of architecture, of all that Jefferson held dear: proportional spaces inside and outside a house filled with light and a mixture of native and introduced trees, flowers and shrubs, also planted in balanced clumps around the house, with some providing shade—all offering him the seclusion and intimacy of family and nature he craved. After Jefferson died, he left Poplar Forest to his grandson Francis Eppes, who was the son of Jefferson's daughter Maria Jefferson Eppes. The house was soon sold and passed into the hands of several families afterward, who adapted the house to their needs. Thomas Jefferson's Poplar Forest was designated a National Historic Landmark by the secretary of the interior and was nearly lost to development before being rescued in 1984 by a group of local citizens that sought to preserve it for the cultural and educational benefit of the public. The house was opened on a regular basis to the public for the first time in 1986, in its "before restoration" state, and a visit offers

Restoration craftsman at work. *Courtesy Thomas Jefferson's Poplar Forest. Photograph by John Henley.*

the unique opportunity to observe a "live" archaeological dig and historic restoration in progress, as efforts to reveal and restore Thomas Jefferson's vision for his personal retreat continue.

Poplar Forest is open daily from March 15 through December 30 (closed on Easter, Thanksgiving Day, Christmas Eve and Christmas Day) from 10:00 a.m. until 5:00 p.m. and on weekends from January through March. Admission includes a guided house tour and self-guided exploration of exhibits in the lower level of the house, the wing of offices, the ornamental grounds and the slave quarter site. Guided tours of the octagonal house begin at 10:00 a.m. and run every half hour, with the last tour of the day beginning at 4:00 p.m. For more information about Thomas Jefferson's Poplar Forest, visit poplarforest.org or call 434-525-1806. The site is located on Route 661, but be sure to put in the following if using GPS: 1542 Bateman Bridge Road. The organization is in the process of planning for a new entry and drive, which will lead visitors through fields and forests to the house and visitor's area. Be sure to check the website for updated directions, especially in 2019 and beyond.

# JEFFERSON'S BLUE RIDGE MOUNTAINS

## THE MONACAN INDIAN NATION, THE PEAKS OF OTTER AND THE NATURAL BRIDGE

*It may be regarded as certain that not a foot of land will ever be taken from the Indians without their own consent. The sacredness of their rights is felt by all thinking persons in America, as much as in Europe.*
—*Thomas Jefferson, "Answers to de Meusnier Questions," 1786*

American interest in, and exploitation of, Native Americans in North America dates from at least the first settlement of the Colony of Virginia in 1607. In many ways, it is no surprise that Thomas Jefferson would have had an unusually strong interest in the indigenous people of Virginia—first through his father, Peter Jefferson, and second due to his own curiosity and love for the Virginia landscape. Discussed earlier, his father's contributions to the map of Virginia in 1753 were significant, considering it was the first to follow Captain John Smith's map of the Chesapeake in 1612. Smith was an explorer and settler of Jamestown (today part of "America's Historic Triangle" of Williamsburg-Jamestown-Yorktown, a tourism partnership) whose map is considered a masterpiece, both for its geographic accuracy and for the amount of information he documented on Native American society. The names of two hundred Indian villages and locations were embedded in his map, many of which survive as place names today.

Smith traveled 2,500 miles between 1607 and 1609—mostly by water—in a series of short expeditions to explore Virginia and create the map, documenting river ways inland that would eventually become settled by

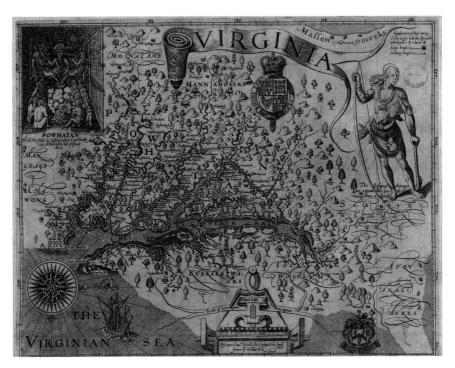

John Smith and William Hole, *Map of Virginia*, 32 x 41 cm., London, 1624. *Courtesy of the Library of Congress.*

Anglo-Europeans moving ever farther west. Most importantly for us, Smith explored the James River and its tributaries, the major waterway connecting the Blue Ridge Mountains to the Chesapeake Bay and the Atlantic Ocean. On his map, in the upper left corner, can be seen small mountains and the name "Monacans," the name for the Native Americans living in sparse settlements represented by longhouses in central Virginia. This is the area where Peter Jefferson settled, in the Piedmont, with views of the Blue Ridge Mountains. Thomas Jefferson's Monticello and Poplar Forest both contain archaeology collections numbering in the thousands of artifacts of material excavated and collected on site, demonstrating the history of indigenous people who lived in this area for thousands of years. Archaeologists continue to find and document prehistory, but Monacan people and culture remain a living part of central Virginia today. For more information on the Captain John Smith Chesapeake National Historic Trail and the role of the James River therein, America's first water trail, see https://www.nps.gov/cajo/planyourvisit/maps.htm. You'll need a canoe or kayak for your own explorations.

*Left*: Serrated Kirk projectile point, chert, Early/Middle Archaic Period (approximately 6200–5700 BCE), found just above the subsoil in the carriage turnaround. *Courtesy of Thomas Jefferson's Poplar Forest.*

*Below*: Stanly stemmed projectile point, chert, Middle Archaic Period (approximately 6200–5000 BCE), surface find. *Courtesy of Thomas Jefferson's Poplar Forest.*

# THE MONACAN INDIAN NATION

*If they wish to remain on the land which covers the bones of their fathers,* [we adjure them] *to keep the peace with a people who ask their friendship without needing it, who wish to avoid war without fearing it. In war, they will kill some of us; we shall destroy all of them.*

—*Thomas Jefferson to Henry Dearborn, 1807*

Thomas Jefferson, perhaps more than any other American leader, had a long-standing interest in Native American people and culture that preceded his presidency. The college he attended, William & Mary, had a school within its campus for teaching Native Americans—as well as introducing them to Christianity. But Jefferson knew and was acquainted with Native Americans, whom he called "aboriginal inhabitants" or, like others of his time, "savages," before going to Williamsburg to study. Growing up at Shadwell, Thomas had met the Cherokee chief Ontassete, who had given him a gift of a canoe paddle when he was a boy. Thanks to his father, Jefferson knew well how to canoe and portage, but the gift was symbolic, due to Peter Jefferson's many relationships with Native Americans on the western frontier. For Thomas Jefferson, relationships with Indians would become more fraught as he became an adult and took on different political positions; on the one hand, Jefferson wanted peace with Native Americans, symbolized by the "peace medal" struck in 1801. Medals like these were intended as political gifts to solidify relationships—the crossing of the peace pipe and hatchet demonstrated this visually, while the words "peace and friendship" surrounded the shaking hands of the men from different cultures. But equally so, Jefferson did not turn away from the idea that force would have to be used if Native Americans threatened white Americans, demonstrated very clearly in the quote above from just a few years later. Today, Andrew Jackson is most often associated with the policy of Indian removals, but it was Thomas Jefferson who began that conversation at the national level, opening the door to miserable events such as the Trail of Tears.

The paradox of Thomas Jefferson's American character—seen in his statements about liberty, on the one hand, while at the same time keeping people in bondage—is played out again in his ideas and sentiments about Native American people and culture. For example, in the spring of 1762, just before turning nineteen, longtime friend Dabney Carr told Jefferson that Cherokee chief Ontassete would speak to his

Indian Peace Medal of Thomas Jefferson, bronze, 1801. *Courtesy of the Yale University Art Gallery, 2001.87.23671.*

people who were camped just outside town that evening. Ontassete was about to journey across the Atlantic with two other Native American representatives to present his case to the king of England, a tradition going back to Elizabethan times. That evening, he went with Carr to listen to Ontassete speak, and Jefferson later wrote about this memory to John Adams in 1812, when he was sixty-nine years old, the image of the evening seared in his memory:

> *So, in answer to your inquiries concerning Indians, a people with whom, in the early part of my life, I was very familiar with, and acquired professions of attachment and commiseration for them which have never been obliterated. Before the Revolution they were in the habit of coming often and in great numbers to the seat of government, where I was very much with them. I knew much the great chief Ontasseté, the warrior and orator of the Cherokees; he was always the guest of my father, on his journeys to and from Williamsburg. I was in his camp when he made his great farewell oration to the people in the evening before his departure for England. The moon was in full splendor, and to her he seemed to address himself in prayers for his own safety for the voyage, and that of his people during his absence; his sounding voice, distinct articulation, animated action, and the solemn silence of his people at their several fires filled me with awe and veneration, altho' I did not understand a word he uttered.*

When Ontassete traveled to London in 1762 with Ostenaco, whose portrait was painted by Sir Joshua Reynolds, they were instant celebrities and continued to feed the European fascination with "exotic" native culture. Remember, Pocahontas had been taken by her husband, the Virginian settler John Rolfe, to England a century earlier and had died there. This fascination with Native American and other nonwhite peoples is seen in the questions posed by François Barbé-Marbois, the French legation to the American Continental Congress. In 1780, Barbé-Marbois inquired about indigenous American people and culture, among other "curiosities" of the new country, its North American geography and the characteristics of each state. Jefferson was given the questionnaire to answer, and in doing so, he ended up writing his first and only book, *Notes on the State of Virginia*. In addition to this writing, earlier Jefferson had excavated an Indian burial mound close to Monticello to learn more about the cultural habits of the Monacans, and he used a scientific approach to do so—excavating the burial mound with care and precision and cutting into it so that the layers of earth (and bones) were exposed to careful study. Although the practice of digging into grave sites is not only frowned upon but also illegal today, the science and ethics of archaeology were not yet established; later, for this introductory attempt at scientific excavation and documentation, Jefferson would be called the "Father of American Archaeology."

Jefferson wrote about the Monacans in his *Notes on the State of Virginia*, saying that the tribe resided above the falls at the Forks of the James River and that their 1669 population then numbered only 30, with a total tribe of only 120. Today, the Monacan Nation has more than 2,000 members and is one of eleven tribes recognized by the Commonwealth of Virginia and was recently recognized by the federal government as well, after decades of work. The burial mound excavated by Jefferson was one of thirteen documented in central Virginia, but this particular mound is now gone. Close to the Rivanna River, it may have washed away. Thomas Jefferson was familiar with Monacan culture due to these experiences but also because of the fact that the Monacans worshiped the Natural Bridge as the "Bridge of God"—Jefferson owned the sacred site for more than five decades, between 1774 and his death in 1826. Today, you can learn about Monacan culture at Natural Bridge State Park, where a re-created Monacan village along Cedar Creek is included in the entry fee, or you can visit the Monacan Nation at Bear Mountain in Amherst, Virginia, halfway between Charlottesville and Lynchburg. There a historic 1870 log cabin church turned schoolhouse, a small museum and Virginia Historic Highway marker share the Monacan

*Above*: Monacan Indian Nation headquarters, with Bear Mountain Indian Mission School, Virginia highway marker and Monacan Indian Museum sign. *Author's collection.*

*Left*: Monacan Indian Museum, Amherst, Virginia. *Author's collection.*

story. But as stated, Monacan culture is not just about the past—every spring the Monacan Indian Nation hosts a large powwow, drawing people from across the Commonwealth and beyond, to celebrate indigenous heritage and culture. For more information on visiting the Monacan Indian Museum, which is open by appointment, visit the website at https://www.monacannation.com/ancestral-museum.html.

# THE NATURAL BRIDGE

*It is impossible for the emotions arising from the sublime to be felt beyond what they are here; so beautiful an arch, so light, and springing as it were up to heaven! The rapture of the spectator is really indescribable!*

—*Thomas Jefferson,* Notes on the State of Virginia, *1781*

Along the eastern edge of the Blue Ridge Mountains, an extremely long mountain crest that runs from just north of the Potomac River on the Virginia-Maryland border south all the way to northern Georgia, is found a limestone arch carved out of water millions of years ago. This tall, narrow passage (you can both walk underneath it or drive over it) was, for Thomas Jefferson, a place that drew his great admiration—even passion—for more than five decades. The Natural Bridge, as of 2016, is a site of the Virginia State Park system, but it has been many more things: sacred landscape for the Monacan Indians; edge of the wilderness for the young United States; tourist site during the Victorian era; tourist site again in the twentieth century when motels, wax museums and other roadside tourist attractions were in vogue; and even today the site of biblical storytelling from an evangelical viewpoint. Due to the historic site's changeover from private to public hands, the Natural Bridge now has the opportunity to refocus on the environmental and historic aspects of the landscape, introducing new generations of fans to a landscape feature seemingly more common to the Southwest than to the East.

The Natural Bridge is a limestone arch over Cedar Creek 215 miles high and 90 feet long that has been an admired natural wonder since the eighteenth century, not only in the United States but also in Europe, as demonstrated in a print (shown here) made for the French market. According to legend, George Washington surveyed the bridge and cut his initials into one of the interior walls. Thomas Jefferson was so enthralled by the Natural Bridge that he purchased it and 157 surrounding acres from the Crown in 1774. He wrote several times about the arch, not surprisingly, most thoroughly in his book, *Notes on the State of Virginia*:

*The Natural Bridge, the most sublime of Nature's works.... The fissure, just as the bridge, is by some measurements 270 feet deep, by others 205 feet deep...it is about 45 feet wide at the bottom and 90 feet at the top... its breadth in the middle, is about 60 feet, but more at the ends, and the thickness of the mass at the summit of the arch, about 40 feet.*

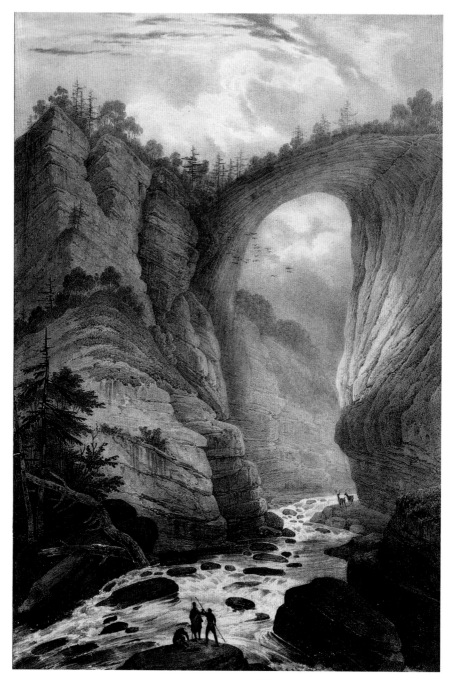

After Jacques Gerard Milbert (French, 1766–1840), *Amerique Septentrionale—Etat de Virginie. N. 53, pl. 3….View of the Natural Bridge*, n.d. Lithograph by Bichebois and Adam, after Milbert, Roberts and Jefferson, Sheet: 47.6 x 34.7 cm. (18¾ x 13 11/16 in.). *Mabel Brady Garvan Collection, Yale University Art Gallery, 1946.9.2088.*

According to Jefferson, standing on the bridge and looking down at the river below, "You voluntarily fall on your hands and feet, creep to the parapet, and peep over it." This need to document and measure nature, compare it to other places and fall into sublime wonder was a part of Enlightenment thought and activity on both sides of the Atlantic. Jefferson was an active participant in the Enlightenment, sharing his information through the publication of his book and also in the display of artifacts and prints at Monticello, including prints of the Natural Bridge, one of which was in the dining room. After his travels to Europe, Jefferson was influenced to collect images of the New World, or America, that could compete with the wonders of the Old World. According to art historian Anna O. Marley, Jefferson wrote to Maria Cosway, his intimate friend in France, that "artists should make America's remarkable landscapes 'known to all ages' describing the 'Cascade of Niagara,' the 'Natural Bridge' in Virginia and the 'Passage of the Potowmac' thro the Blue Mountain's at Harpers Ferry, West Virginia [then part of Virginia, and the place from which Thomas Jefferson viewed the confluence of the Shenandoah and Potomac Rivers with architect Benjamin H. Latrobe], as among the natural wonders 'worth a voyage across the Atlantic to see.'" Jefferson hung prints and paintings of these American natural wonders, including a painting of the Natural Bridge by William Roberts that had been gifted to him by the artist but which later went missing when the contents of Monticello were auctioned off.

As Gene Crotty documented in his book *Jefferson's Western Travels Over the Blue Ridge Mountains*, Jefferson visited the Natural Bridge at least six times between 1773 and 1821. Jefferson first saw the Natural Bridge in 1767 with the help of a guide, as it was located at the edge of civilization where the "West" began, and drew a diagram of it on the flyleaf of his "Farm Book." It's important to remember that when Jefferson and others traveled to see the Natural Bridge, there was no hotel waiting with warm beds and warm food as there is today. When Jefferson visited the Natural Bridge for the first time, he was a twenty-four-year-old man and there was no such thing as a United States of America. King George III was on the throne in England and had absolute power over countries and colonies that spread around the globe. In other words, this George owned a lot of land and could do with it as he pleased. Unlike George Washington, who traveled to the Blue Ridge Mountains and surveyed Natural Bridge, George III never stepped foot in his American colonies.

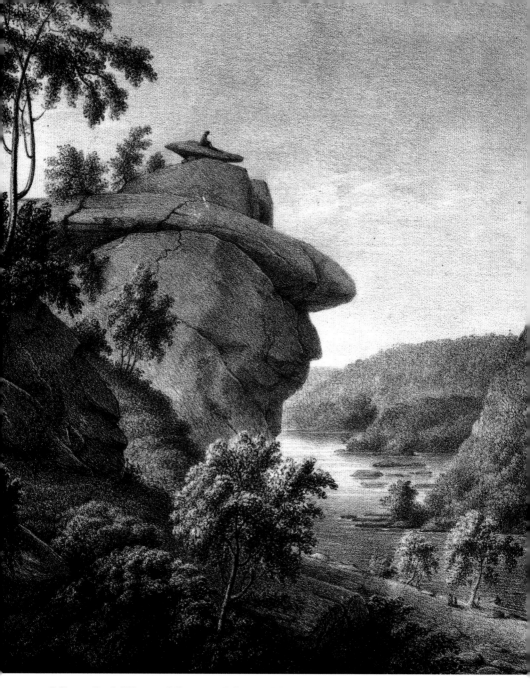

Jefferson Rock, Library of Congress. Jefferson visited this site on October 25, 1783, writing in his *Notes on the State of Virginia*, "The passage of the Patowmac through the Blue Ridge is perhaps one of the most stupendous scenes in Nature. You stand on a very high point of land. On your right comes up the Shenandoah, having ranged along the foot of the mountain a hundred miles to seek a vent. On your left approaches the 'Potawmac' [Potomac], in quest of a passage also. In the moment of their junction, they rush together against the mountain, rend it asunder, and pass off to the sea....This alone is worth a voyage across the Atlantic." *Courtesy of the Library of Congress.*

But the fame of Natural Bridge was so great that he surely knew of its location and great beauty from its continual appearance in print culture.

Jefferson actually spoke about building a small retreat there. "I sometimes think of building a little hermitage at the Natural Bridge and of passing there a part of the year," he wrote in 1786 from Paris to a friend. A two-story log cabin near the bridge was there already, and since many Americans were aware of the Natural Bridge and began visiting the site, Jefferson instructed his caretaker, a free black man named Patrick Henry, to record the names of guests in a book. The other Patrick Henry ("Give Me Liberty, or Give Me Death"), Sam Houston and John Marshall all visited—even Daniel Boone, a real man who became a symbol of rugged American individualism and western exploration. Jefferson's last trip to the Natural Bridge happened in 1821. Although Jefferson was seventy-eight years old and suffering from rheumatism, he was able to ride horses with ease, as Crotty documented in Jefferson's words: "I am little able to walk, but ride freely without fatigue. No better proof than that on a late visit to the Natural Bridge I was six days successively on horseback from breakfast to sunset."

You can visit both Jefferson Rock and the Natural Bridge in Virginia. Jefferson Rock is part of Harper's Ferry National Historical Park, which resides in West Virginia, Virginia and Maryland. The Appalachian Trail passes close by—visitors find Jefferson Rock by taking the path between the Lower Town and Camp Hill areas of the park. For more information, see https://www.nps.gov/hafe/learn/historyculture/jefferson-rock.htm. The Natural Bridge State Park consists of 1,540 acres in Rockbridge County three miles off of I-81, at Routes 11 and 130. The GPS address is 6477 South Lee Highway, Natural Bridge, Virginia, 24578, and the phone number is 540-291-1326. On site are a gift shop, food services and the Natural Bridge Historic Hotel & Conference Center—once called a "grand lady" with 118 guest rooms, a full-service dining room, a tavern and meeting space. In addition, there are walking trails and special programs throughout the year such as carriage rides and luminary nights. For more information see http://www.dcr.virginia.gov/state-parks/natural-bridge#general_information.

# THE PEAKS OF OTTER

*The height of our mountains has not yet been estimated with any degree of exactness….The mountains of the Blue Ridge, and of these the Peaks of Otter, are thought to be of a greater height, measured from their base, than any others in our country, and perhaps in North America.*

—*Thomas Jefferson*, Notes on the State of Virginia, *1781*

As with his great love for the Natural Bridge, Jefferson took to measuring another natural feature of the Blue Ridge Mountains: a series of ranges near his Poplar Forest plantation called the Peaks of Otter. Named, perhaps, for the word *otarri*, meaning "lofty place" in Cherokee, the Peaks of Otter are three mountain peaks in the Blue Ridge Mountains overlooking the town of Bedford, Virginia. These peaks are Sharp Top (3,862 feet, which Jefferson called the "sharp one"), Flat Top (3,994 feet) and Harkening Hill (3,372 feet). Jefferson was determined to measure the height of the Peaks of Otter because, for a time, he believed them to be the tallest mountains east of the Mississippi, even though the White Mountains in New Hampshire were thought by others to be taller. In order to do this work, Jefferson needed to gather scientific instruments and mathematical materials at Monticello, travel to his retreat house Poplar Forest, make the excursion across the Piedmont and up the Peaks of Otter and spend time afterward with calculations creating geometric diagrams. Jefferson purchased many of his scientific instruments—the ones he used, for example, to calculate the height of the Peaks of Otter—in England when he traveled there to see John Adams in 1786. Because Jefferson considered mathematics the "passion of my life," undertaking this kind of Enlightenment project was nothing less than a "delicious luxury" to him. As he wrote four years earlier in 1811, "Having to conduct my grandson through his course of mathematics, I have resumed that study with great avidity. It was ever my favorite one. We have no theories there, no uncertainties remain on the mind; all is demonstration and satisfaction."

Jefferson made two trips to the Peaks of Otter in 1815. The first was with José Corrêa da Serra, a Portuguese botanist and a frequent guest at Monticello, and their mutual friend Francis Walker Gilmer, a young man whom Jefferson called the "best educated young man of the state with the most amiable disposition" and who became an ardent disciple of Corrêa and, later, the first professor of law at the University of Virginia. The three

Bill Barker as Thomas Jefferson, taken on Sharp Top, Peaks of Otter, September 2016. *Photograph by Jeffrey Nichols.*

made plans to hike the Peaks, "botanizing" together. Jefferson was seventy-two years old at the time, while Corrêa was a young sixty-five. The retired but still active Jefferson rode part of the way there—visitors can do the same today, although on a shuttle bus—and then hiked the steep, rocky ascent to the pinnacle. Jefferson then returned one month later, traveling to his friend Christopher Clarke's plantation called Mount Pleasant, from where he measured the Peaks of Otter from the base of the mountains, only trekking to the pinnacle of Sharp Top to fix the latitude measurements. It is likely he did not climb up Flat Top (which is a longer and harder climb than Sharp Top), but rather determined the latitude from Sharp Top. Jefferson spent five days in the field taking measurements and then five days at home at Poplar Forest making calculations and drawing diagrams.

Jack Gary, the director of archaeology and landscapes at Thomas Jefferson's Poplar Forest, gives a talk on Jefferson's "subject of uncertain conjecture" every fall at the Peaks of Otter Lodge, with a walk to the pinnacle of Sharp Top afterward with Mr. Thomas Jefferson himself (in the guise of Bill Barker). For Gary, one of the most enlightening aspects of Jefferson's measurement project is

*Thomas Jefferson's dogged determination to make the measurements, make them accurately and then disseminate that information as a contribution to understanding the world around us—despite the results contradicting his earlier claims. He calculated Sharp Top to be 2,954.5 feet tall from its base (obtaining an elevation from sea level at that time was not possible) and Flat Top to be 3,103.5 feet tall from its base, both well below the 4,000 he had suggested in 1781 in Notes on the State of Virginia. Within two weeks of making the measurements his calculations were published in*

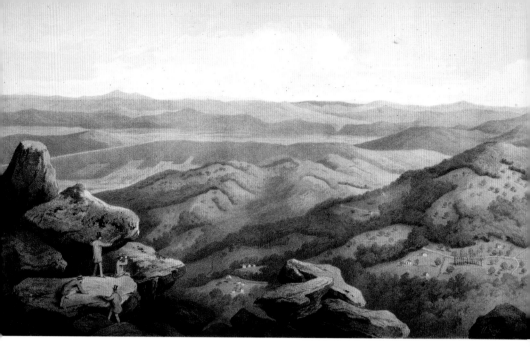

Rau and Son (German) after Edward Beyer (American, 1820–1865), *Album of Virginia / View from the Peak of Otter Bedford County, VA, no. 1 (above)* and *no. 2 (opposite)*, 1857. Lithographs in monotone, sheet: 43 x 56.5 cm. (16 15/16 x 22¼ in.). *Mabel Brady Garvan Collection, Yale University Art Gallery, 1946.9.1822 and 1946.9.1823.*

*newspapers in Lynchburg, Richmond, and Washington, D.C. The editor of the Daily National Intelligencer in Washington prefaced the calculations with, "We copy from the Lynchburg Press the following nice Geometrical calculations, which are the result of the unwearied industry and scientific character of the venerable JEFFERSON, who is now on a visit to his farm at Poplar Forest, in that neighborhood. It is delightful to witness the serenity and elasticity of the eve of a well-spent life, as exemplified in the present pursuits and habits of the illustrious Republican philosopher.*

Today, after the work of the Works Progress Administration and Civilian Conservation Corps in the 1930s created stone steps and inserted some railings, visitors ascend with some effort. Most folks come to the Peaks of Otter to hike Sharp Top and Flat Top, with their magnificent views of the valley below, the Piedmont stretching to the east and the Blue Ridge Mountains rolling like green waves seemingly to the horizon. If you take the Sharp Top trail, which is 3.6 miles round trip (about two hours up and less than one hour down), a difficult straight-up hike, you will be rewarded with stunning views. A stone structure, built much earlier in 1858 by the Otter Peaks Hotel during the era of Victorian tourism, and

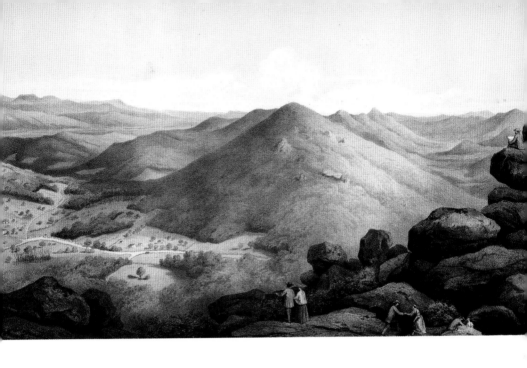

which the Blue Ridge Parkway Foundation is hoping to restore in 2018, serves as a shelter for hikers.

The Blue Ridge Parkway Foundation helps to maintain the Blue Ridge Parkway, which is a 469-mile scenic drive that winds its way from the border of Shenandoah National Park in Virginia to the entrance of the Great Smokey Mountains in Tennessee/North Carolina. The Peaks of Otter area at milepost 85.6 contains many tourist-friendly amenities, including a beautiful lodge (with restrooms and gift shop), a camp store, a campsite and a National Park Service visitors' center with displays (and more bathrooms). There are plenty of trails in addition to Sharp Top, Flat Top and Harkening Hill, from a short 1.5-mile walk around Abbott Lake to longer trails up to the Johnson Family Farm, the place where you can see how families in the nineteenth and early twentieth centuries lived in rural, mountainous areas—until the park service possessed their land to turn it into a parkway for the people and the burgeoning automobile age. For more information on hiking, see https://www.nps.gov/blri/planyourvisit/peaks-of-otter-mp-85-6.htm. For lodging and dining, see the Peaks of Otter Lodge, 85554 Blue Ridge Parkway, Bedford, Virginia, 24523.

Costumed participants on the Thomas Jefferson and the Peaks of Otter walk, September 2017. *Author's collection.*

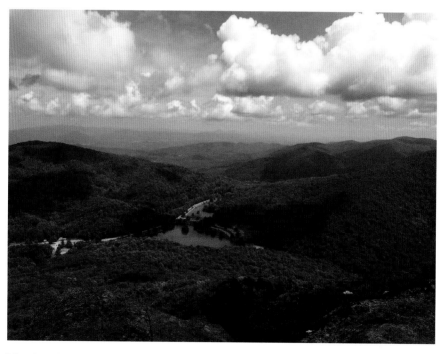

View from Sharp Top over Abbott Lake and the Blue Ridge Mountains, 2016. *Author's collection.*

## THE BLUE RIDGE MOUNTAINS

There are other areas in the Blue Ridge Mountains, accessible from the Blue Ridge Parkway and Shenandoah National Park, both units of the National Park Service, that have Jefferson connections for you to visit. For example, Petite's Gap, at milepost 71.1, is a low point in the mountains where Jefferson would cross from the Natural Bridge into Bedford County, where Poplar Forest was located. The elevation is 2,369 feet—the "crest of the Blue Ridge"—more than 1,000 feet lower than the Peaks of Otter. The Gap, also called "Poteets," was a place for rest where Jefferson might have stayed during his travels on horse and by carriage. The Appalachian National Scenic Trail, a 2,144-mile public footpath from Maine to Georgia, crosses over Petite's Gap road, and you can park your car there and do some of the walk. A quarter of the Appalachian Trail lies in Virginia, some of it roughly parallel to, but generally many miles removed from, the Blue Ridge Parkway. It crosses the Parkway two times in this 70-mile stretch, including here at Petite's Gap. It is then close to the Parkway, with several crossings over the paved parkway before crossing into the George Washington and

Blackrock Summit, Shenandoah National Park, milepost 84.4, 2017. *Author's collection.*

Jefferson National Forests in the Appalachian Mountains—a 1.8-million-acre wilderness area with hiking trails. For more on the George Washington and Jefferson National Forests, see https://www.fs.usda.gov/gwj.

A second spot related to Thomas Jefferson in the Blue Ridge Mountains is farther north in Shenandoah National Park (the Blue Ridge Parkway and Shenandoah National Park are directly connected at Rockfish Gap near Waynesboro, Virginia; Shenandoah charges a twenty-dollar vehicle fee for entry, while the Blue Ridge Parkway is free). Blackrock Summit, at milepost 84.4 on Skyline Drive in Shenandoah National Park, offers a short one-mile walk with an excellent view and a tremendous rocky talus slope. Here in these rocks—referred to as caves in some literature—Thomas Jefferson is said to have hid the state seals of Virginia during the Revolutionary War. Although this story is suspect, repeated in popular literature but unsubstantiated by scholars, Jefferson would certainly have appreciated seeing the geology of Blackrock Summit. It is, in fact, the remains of the bottom of an ancient ocean, predating the Appalachian Mountains themselves. The talus slope was actually once a cliff, now slowly disintegrating. You can walk around the slope and back to the trailhead or veer off on the Appalachian Trail to create a slightly longer route. For more information on Shenandoah National Park, see https://www.nps.gov/shen/index.htm.

# JEFFERSON'S WORDS

## BOOKS, JOURNALS, LETTERS AND LIBRARIES

*I cannot live without books; but fewer will suffice where amusement, and not use,
is the only future object.*
—*Thomas Jefferson to John Adams, June 10, 1815*

The practice of reading and writing were central to Thomas Jefferson's existence. Paper, ink, pens, desks, leatherbound books, bookshelves and the creation of libraries were the stuff that Jefferson concerned himself with—owning more than nine thousand books over the course of his life. Jefferson spent hours reading every day, while also pushing out approximately 19,000 letters over the course of his lifetime—about 1,200 of them to James Madison alone. In turn, he received more than that. In the twentieth century, books became cheap commodities costing less than a dollar, printed on industrially made acidic paper that quickly turned pages brown. But books and paper itself were luxuries for Americans until the twentieth century, and today, in the digital world of electronic reading, the allure of printed books has returned. Artists craft hand-made examples, rare books sell for hundreds and thousands of dollars and libraries have become, once again, centers of American society. The practice of building "Little Free Libraries" in public spaces has revived the goodwill that comes with the sharing of books and knowledge—something Thomas Jefferson did often in his own life, although on a larger scale, through the creation of libraries, by lending books to others and through the creation of library lists for his friends, the Library of Congress and the University of Virginia.

In one of the early episodes in Jefferson's life, he recounted that in Williamsburg he often lent books to Patrick Henry, but Henry would return them virtually unread—he was too busy being sociable. But before going to college, Jefferson grew up surrounded by books at Shadwell. There were £200 worth of books when Shadwell burned in 1770, including the first library Jefferson had put together. Peter Jefferson, although not college educated, was learned and collected books—a visual and intellectual symbol of the planter class in the British Atlantic world to which he belonged and aspired to grow into more fully. Peter's library was small in comparison to others—Jefferson inherited forty books when his father died—but the value of books in the home (there were no public libraries at the time in cities, much less in rural areas such as central Virginia) clearly made an imprint on him. When Jefferson went to study with Reverend James Maury in 1758, he was further exposed to the larger world through Maury's own collection of almost three hundred books. Twelve years later, Jefferson, at age twenty-seven, had acquired his own collection of almost four hundred books. Later in life, Jefferson wrote, "Sensible that I labour grievously under the malady of Bibliomanie, I submit to the rule of buying only at reasonable prices, as to a regimen necessary in that disease."

The economics of books was also something Jefferson dealt with, not only in the purchasing of books but also in their value as capital. Jefferson, in fact, sold a set of his books—approximately 6,707 of them—to the Library of Congress in 1815 for $23,950 after the British invaded Washington, D.C., and burned both the United States Capitol and the Congressional library during the War of 1812. Jefferson's books became the core of the library and are currently displayed together in the exhibit "Thomas Jefferson's Library" in the Jefferson Building, although the librarians of Congress have spent years re-creating the original Jefferson library because Congress burned again in 1851, destroying two-thirds of the original Jefferson book collection.

Jefferson bought and collected books wherever he was—from Williamsburg to Philadelphia, New York, France and Washington, D.C. Looking back at his time in France for five years as minister, Jefferson wrote to a friend:

*While residing in Paris, I devoted every afternoon I was disengaged, for a summer or two, in examining all the principal bookstores, turning over every book with my own hand, and putting by everything which related to America, and indeed whatever was rare and valuable in every science. Besides this, I had standing orders during the whole time I was in Europe, on its principal*

Bust of Thomas Jefferson, Thomas Jefferson Building, Library of Congress, Washington, D.C. *Photograph by Carol Highsmith, 2007. Courtesy of the Library of Congress.*

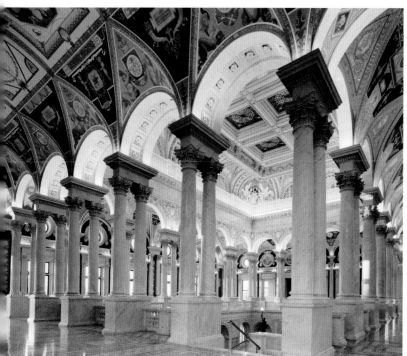

Great Hall, Thomas Jefferson Building, Library of Congress, Washington, D.C. *Photograph by Carol Highsmith, n.d. Courtesy of the Library of Congress.*

*book-marts, particularly Amsterdam, Frankfort, Madrid, and London, for such works relating to America as could not be found in Paris.*

In addition to his purchases directly from booksellers or through book agents, people such as George Wythe left Thomas Jefferson entire book collections when they died. All of these books found a home after the Revolutionary War (Jefferson kept them in hiding) at both of his homes, Monticello and Poplar Forest, where he created libraries. At Monticello, Jefferson's library consisted of more than 6,500 volumes, which by then had become the largest private library in the United States. Not surprisingly for a man who had begun a series of journals to track every aspect of his house and plantation, Jefferson also kept a catalogue of books of his library at Monticello, which he wrote in 1783, on the heels of his work on his first and only book, *Notes on the State of Virginia*. Jefferson's book collection included titles on architecture, literature (Shakespeare's *King Lear* is mentioned in one Jefferson letter—suggesting Jefferson identified with Lear because both had daughters), ancient and modern history, science and natural philosophy.

*Notes on the State of Virginia*, a compendium of facts as Jefferson saw them combined with his personal philosophies in regards to good government, was instigated by a series of questions posed by François Barbé-Marbois, the secretary of the French delegation in Philadelphia, who, via the Continental Congress, asked each state in the Union for information. The Enlightenment project was passed on to him by James Monroe's uncle, and Jefferson could not help but relay the answers while also arguing for the progress of rational thinking in the form of democratic institutions and an educated populace. *Notes on the State of Virginia* has been called an "American classic" and the "most important scientific and political book written by an American" prior to 1785. Reading through the chapter titles of the *Notes* gives some sense of the "boundless curiosity" of Jefferson's mind. From statistical documentation on birds of North America to lists of Native American tribes, the location and uses of rivers and sea ports and all manner of local political and cultural characteristics, Marbois's questions were an opportunity to arrange the notes he had been collecting for years already on Virginia, which Jefferson called "my own native country."

At first, Jefferson did not want his book published and thus had only enough copies printed in France—where the cost was much lower than printing in America—for close friends. But soon the book gained attention from growing numbers of people who wanted a copy, and Jefferson was forced into working with an American publisher, although he also took the

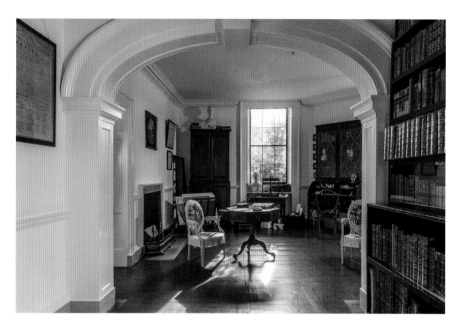

Library at Monticello. *Thomas Jefferson Foundation at Monticello. Photograph by Walter Smalling.*

time to continue refining the book through its various publication phases, adding or editing sections as new information became available. Like Monticello itself, a project that was in a constant state of reworking, *Notes on the State of Virginia* became, for Jefferson, "nothing more than the measure of a shadow, never stationary, but lengthening as the sun advances, and to be taken anew from hour to hour."

Poplar Forest, a place of respite for Jefferson, away from public scrutiny and public demand, was the site where Jefferson began his writing project. Later, when he built an octagon house on the plantation, his Neoclassical villa became the home of his second personal library. The library at Poplar Forest numbered about one thousand volumes, including works in the six languages Jefferson could read in addition to English (French, Italian, Spanish, Greek, Latin and Anglo-Saxon). Jefferson's library at Monticello had book cases crafted by joiners that were more containers for books than full bookcases. The purpose of this was to allow Jefferson to travel with his books, which he did, to places like Poplar Forest, a three-day journey by horse or carriage. The book containers, made of pine (a light, soft wood), would be strapped in and carried for the journey and set up inside the library at Poplar Forest for access. Many of these books were in a petite format size of about three

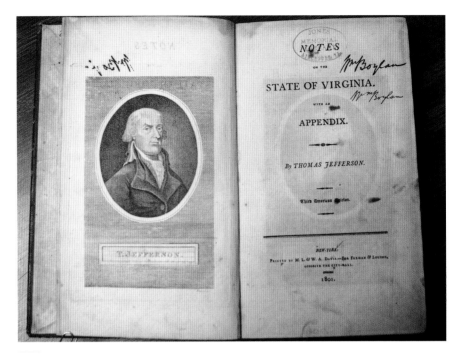

*Notes on the State of Virginia*, 1801 edition, printed in New York by M.L. & W.A. Davis. *Courtesy of Thomas Jefferson's Poplar Forest. Photograph by Michelline Hall.*

by five inches. Travis McDonald, the director of architectural restoration at Poplar Forest, has studied Jefferson's "bibliomanie" in order to begin re-creating some of the book cases for the library. In his research, McDonald has found that "unique to Poplar Forest were the 19 volume set of Greek history and the 57 volume set of Buffon's natural history." In addition, there were fifty books of poetry, thirty-one books on ethics, twenty-two books of the romance genre, eighteen books on geography, ten books on medicine, ten books on religion and twenty-seven books on modern history, among many others. His curiosity, and his reading habits, were voracious.

After the publication of *Notes on the State of Virginia*, Thomas Jefferson went through a difficult political period in which he was excoriated by fellow Americans and often in the press (no wonder, he wrote in 1815, "I have given up newspapers in exchange for Tacitus and Thucydides, for Newton and Euclid; and I find myself much the happier"). One of the areas his political opponents pounced on was Jefferson's faith in reason and education over religion, and according to scholar William Peden, he was called a "howling atheist" and a "confirmed infidel" in the media. But of course, Jefferson

had private, personal views of his relationship to god that he was able to separate from the practices of organized religion—just as he believed in the separation of church and state, explicated in his Virginia Statute of Religious Freedom. The phrase "separation of church and state" was, in fact, coined by Jefferson, first appearing in a letter written to the Danbury Baptist Association in 1802.

What perhaps many of his critics did not know was that in addition to *Notes on the State of Virginia* and his personal memorandum books listing expenses, his garden book listing seasonal plantings, and his farm book, which contained information about his farm communities and the enslaved people working there (called the "Roll of the Negroes")—Jefferson also created a specialized Christian book that pulled the morals of Jesus from the New Testament into a leatherbound book he titled "The Life and Morals of Jesus of Nazareth." Known today as the Jefferson Bible, the book, which resides in the National Museum of American History in Washington, D.C., begins with a map of the Mediterranean Sea and the ancient lands of the Levant and proceeds to present eighty-four pages of clippings in Greek, Latin and English. The Smithsonian calls the book a "meeting of Enlightenment thought and Christian tradition as imagined by one of the great thinkers of the Revolutionary Era." The Jefferson Bible is on continuous display on the National Mall, but you can also read the passages he selected on the website

"The Life and Morals of Jesus of Nazareth," Thomas Jefferson, 1820. *National Museum of American History, Smithsonian Institution, Washington, D.C.*

(with help from a digitized translator) at Thomas Jefferson's Bible, http://americanhistory.si.edu/jeffersonbible.

Beyond paper, pen and glue, the other tools of Jefferson's "bibliomanie" consisted of the reading and writing surfaces on which he worked. Jefferson's revolving bookstand can still be seen in his Sanctum Sanctorum at Monticello, where it was crafted by John Hemmings, in addition to a polygraph machine for making duplicates of letters, which Jefferson called "the finest invention of the present age." The lap desk on which he wrote the Declaration of Independence, crafted in Philadelphia, is on display in the same building as the Jefferson Bible in Washington, D.C. Thomas Jefferson depended on reading and writing for fulfillment—his granddaughter Ellen Wayles Randolph wrote that "books were at all times his chosen companions." Perhaps little did he suspect that he himself would become the subject of thousands of books, some of which you can find today at the Robert H. Smith International Center for Jefferson Studies and the Jefferson Library at Monticello. Fifteen thousand books on all aspects of Jefferson's life—including archaeology, botany and agriculture—are available here for researchers. Start your own research by visiting https://www.monticello.org/site/research-and-collections/visit-and-contact-information#hours to search the online catalogue.

# JEFFERSON'S HEALTH

## EXERCISE, DOCTORS, MEDICINE, A BAD STOMACH AND THE JEFFERSON POOLS

*The State of Medicine is worse than that of total ignorance.*
—*Thomas Jefferson to William Green Munford, 1799*

To say that Thomas Jefferson had a problem with doctors is an understatement. Due to his adherence to Enlightenment thinking—which espoused belief in rational, scientific thought and the practice of trial and error, of hypothesis and test—Jefferson was vocally critical of almost everyone who practiced medicine in Virginia and the colonies. He didn't trust traditional doctors because he believed their outdated ways were based in superstition and old wives' tales. This attitude is seen in many passages of his writing or in the writings of others who documented his words. For example, in the presence of his own doctor, Robley Dunglison, Jefferson said directly to one Dr. Everett that "whenever he saw three physicians together, he looked up to discover whether there was not a turkey buzzard in the neighborhood." Although friendly with Dr. George Cabell, whose house, Point of Honor, still exists in Lynchburg and who treated Patrick Henry during his last illness, Jefferson did not use his services in medicine (although he did rent bateaux from him).

Toward the end of his life, Jefferson did come to rely more on doctors for assistance, including Dunglison, who had come from London to teach at the University of Virginia, but he did not believe in the practice of bleeding, as did other Revolutionaries, such as George Washington. To demonstrate how out of step he was in this position, Jefferson went against his good friend, the

Dr. George Cabell, interpreted by Dr. Charles Driscoll, discussing medicine with a visitor on Point of Honor Day, 2015. *Author's collection.*

well-known doctor (and a signer of the Declaration of Independence) Dr. Benjamin Rush of Philadelphia, who believed in bleeding patients, writing, "I was ever opposed to my friend Rush, whom I greatly loved; but who had done much harm, in sincerest persuasion that he was preserving life and happiness all around him."

Jefferson believed in the body's ability to heal itself and preferred to administer medicines to himself whenever possible. His extensive book collection, wide range of acquaintances—including the enslaved people on his plantations—and deep interest in the natural world meant that he pulled knowledge from a variety of sources. Americans across the colonies grew herbs and self-medicated with concoctions and poultices (a mass of material such as plants wrapped in cloth, used to treat inflammation), and this was a practice Jefferson followed, using herbs from his gardens at Monticello, including balm, calomel, hyssop, marjoram, lavender, jalap, rhubarb, quinine, thyme, magnesia and laudanum for medicinal use. But at the same time, Jefferson snubbed most of the medical profession—such as it was in the eighteenth century, when germ theory was unknown. Yet he also believed in the newest thinking in cutting-edge medicine: vaccination for smallpox, a

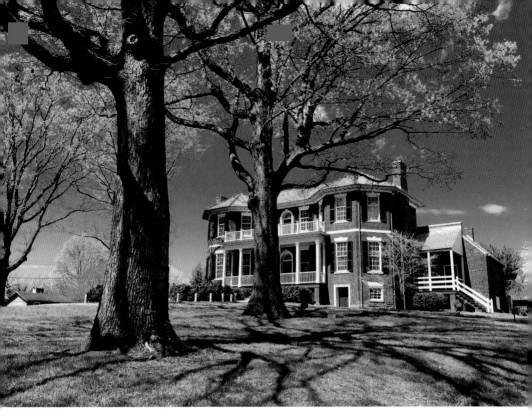

Point of Honor, built by Dr. George Cabell, Lynchburg, Virginia. *Author's collection.*

practice that was difficult. Believing in the scientific theory of vaccination, Jefferson traveled to Philadelphia for inoculation in 1766 and later vaccinated his family, some of the enslaved people at Monticello and even some of his neighbors, at a time when most Americans did no such thing.

Although in good health generally as a young man, health was constantly on his mind, perhaps because of the early death of his father, who advocated dedication to exercise, and just as likely, perhaps, due to the deaths of many family and friends and, eventually, the deaths of most of his children. From a young age, Jefferson was serious about habitually exercising and not smoking, although he grew tobacco at both Monticello and Poplar Forest. Jefferson's morning routine included building his own fire and soaking his feet in cold water, which he credited for his good health. He used lead dumbbells to straighten and strengthen a wrist he injured in France during a visit to his intimate friend Maria Cosway and invented a "wrist pillow" for resting. He ate little red meat—for Jefferson it was considered a side dish instead of the center of the meal—and instead consumed mostly vegetables, writing, "I have lived temperately, eating little animal food…vegetables constitute my principal diet." And though Jefferson is known as America's first wine-lover,

he drank only weak wines and preached what he practiced, saying, "We seldom repent at having eaten too little."

Dr. John Holmes, the author of a book devoted to studying Jefferson's relationship to health, suggested that through the study of health, we can identify with Jefferson not as the writer of the Declaration of Independence or as the architect of Monticello but as an "everyman." Thomas Jefferson, although dedicated to keeping healthy, suffered greatly from headaches and stomach problems as an adult. In later life, Jefferson's stomach problems became acute, resulting in bouts of diarrhea. He also had difficulty urinating, possibly from prostate cancer. His doctor prescribed the opiate laudanum. In typical Jeffersonian fashion, he rode his horse two to three hours a day because he believed it helped his stomach problems. Contemporary doctor Joe Pond of Lynchburg believes that riding may have relieved Jefferson's anxiety and therefore eased his diarrhea. As Dr. Holmes wrote, Jefferson approached his health problems the same way he did everything—with "curiosity, reliance on books and learned individuals, and self-determination." He devised a health regimen and didn't hesitate to tell others about it and suggest they follow suit, writing to Peter Carr on August 19, 1785, that "walking is the best possible exercise. Habituate yourself to walk very far." In addition to riding his horse every day around his plantations, Jefferson also walked every night after supper on the terraces.

Monticello has on display Jefferson's personal chest of medicines—displayed in the Sanctum Sanctorum—and you can visit a turn-of-the-nineteenth-century apothecary shop in Alexandria, Virginia, to see examples of medicine of Jefferson's era. Called the Stabler-Leadbetter Apothecary Museum at 105–107 South Fairfax Street, Alexandria, Virginia, 22314, Martha Washington purchased her medicines there. But for a true immersive health experience, the likes of which Jefferson himself endured, a visit to Warm Springs, Virginia, where the Jefferson Pools are located, is a must.

## THE JEFFERSON POOLS

On a trip made to Rockfish Gap to select the site for the University of Virginia in August 1818, Thomas Jefferson and his friend General James Breckenridge traveled up and over the Allegheny Mountains to spend three weeks at a site that remains, to this day, a bit off of the beaten path for most Jefferson fans—the so-called Jefferson Pools in Warm Springs, Virginia.

These two freshwater pools, fed by warm springs, are open for visitors and bathers, and the drive, up and over the mountains to Bath County, is a spectacular one.

Since the eighteenth century, Bath County has attracted travelers from all over the world to take in the waters. Guests can soak in the mineral-rich Jefferson Pools (formerly called the Warm Springs Pool), one of which is the oldest wooden bathhouse in continuous operation in the United States. Warm Springs was a draw for Jefferson because by his seventies, he had rheumatism, and the baths were purported to help cure such inflammatory disease. Going to soak in warm springs—Jefferson had done something like this already when he was minister to France in the 1780s, traveling to Aix-en-Provence for the mineral waters to help his wrist—became fashionable throughout the nineteenth and well into the twentieth centuries and remains so today. Once there, Jefferson called the waters "first merit."

It's no surprise that Jefferson was attracted to bathing in Warm Springs, a pristine rural location, as the relationship between nature and health was Jefferson's well-established modus operandi. But while there,

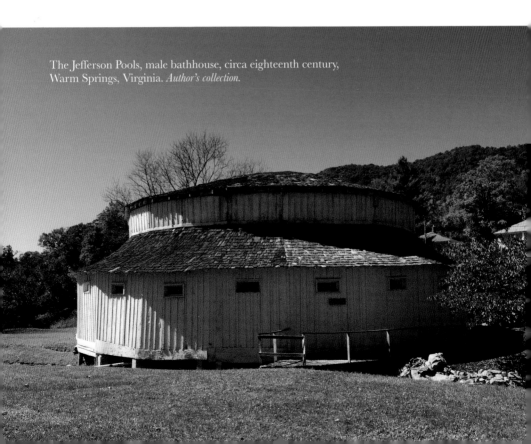

The Jefferson Pools, male bathhouse, circa eighteenth century, Warm Springs, Virginia. *Author's collection.*

The Jefferson Pools

Approximate Partial Analysis (Parts per Million)

| | |
|---|---|
| Dissolved Solids (Calculated) | 388.00 |
| Iron (Fe) | 120.00 |
| Calcium (Ca) by turbidity | |
| Sodium (Na) (Calculated) | 5.40 |
| Bicarbonate (HCO3) | 194.00 |
| Sulphate (SO4) (by turbidity) | 160.00 |
| Chloride (Cl) | 1.50 |
| Nitrate (NO3) | .10 |
| Total Hardness (as CA CO3) | 316.00 |

Signage at the Jefferson Pools, Warm Springs, Virginia. *Author's collection.*

he did complain about boredom, writing to his daughter, Martha, on August 14, 1818:

*I believe I shall yield to the general advice of a three week course. So dull a place, and so distressing an ennui I never before knew. I have visited the rock on the high mountain, the hot springs, and yesterday the falling spring, 15. miles from here; so that there remains no other excursion: to enliven the two remaining weeks….I believe in fact that the spring with the Hot and Warm are those of the first merit. The sweet springs retain esteem, but in limited cases.*

Jefferson's overzealous use of the warm springs—bathing there three times a day for a week, after which he believed he was cured, but then going on to do another two weeks of water treatment—wreaked havoc on his body, his rear end breaking out in boils; he "returned home very ill." Jefferson wrote to his grandson Francis Eppes the next month after his trip, "I am lately returned from the warm springs with my health entirely protracted by the use of the waters. They produced an imposthume [abscess] and eruptions [boils]." Later, the mineral baths at Warm Springs were believed by Jefferson to make his diarrhea return. According to Holmes, Jefferson may have had enemas here, which caused him great distress as he grew older. After experiencing the boils and abscesses garnered from spending too much time in the warm springs, he never returned.

The area of Warm Springs, Virginia, was and is filled with springs. In Jefferson's time, *Falling Spring*, a print displayed in Monticello, was described as something Jefferson saw near Warm Springs, in Augusta County,

Virginia, but its location is unknown today. Bath County is in the Western Highlands, the western edge of the Shenandoah Valley along the border with West Virginia (although both were one state until 1863). In addition to the Jefferson Pools, Bath County is home to the George Washington and Jefferson National Forests.

Today, the Jefferson Pools are owned and managed by the Omni Homestead Resort, a historic hotel located in Bath County with two hot springs that flow into the property. Do visit the hotel; if not to stay overnight, you can walk through the lobby to view a series of murals, painted in the octagon-shaped room, where the story of the area is told from one panel to the next—from the first white explorers of the area to the creation of the bathhouses, Jefferson's visit and the Gilded Age and its diversions. You can also have a drink in the President's Room, which features portraits of all of the American presidents, including the famous Virginians. A library and a sitting room offers images of the Homestead Inn history, while a long hallway displays a faded but still interesting portfolio of prints called the *Album of Virginia*, drawn and engraved by Edward Beyer in 1858, including scenes of the Peaks of Otter and other natural history sites made famous by

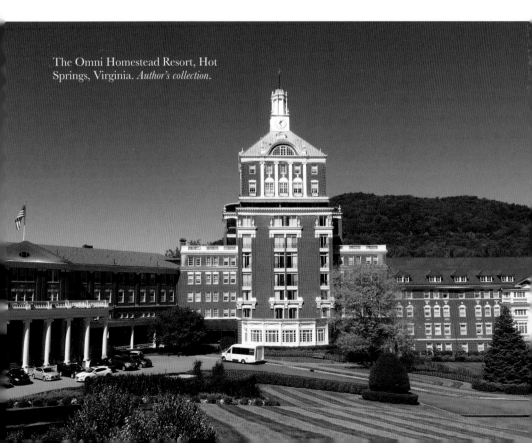

The Omni Homestead Resort, Hot Springs, Virginia. *Author's collection.*

Interior, octagon room with murals, the Omni Homestead Resort, Hot Springs, Virginia. *Author's collection.*

Jefferson. After sitting on the extra-wide front porch for a break, walk to the rear of the property, where multiple springs have been covered over for safe viewing—some with octagon roofs in homage to Jefferson.

At the Omni Homestead Resort, you can make a reservation to visit the Jefferson Pools and take a shuttle there or drive yourself. It is a good idea to make a reservation, whether you do so on your own or through the resort, because spaces are limited and the pools are often crowded, especially on the weekends. Don't be afraid to take the waters—Jefferson may have overdone his visit, but in your reserved time slot, you'll only have enough time for a single soak. When you reach the two octagon-shaped buildings, note that the "Gentleman's Pool" was built first in 1761 and the second structure was added later for women in 1836 (Victorian rules dictated strict separation—before, men and women would alternate bathing times). Although the original building is octagonal, leading some to suggest that it was based on Thomas Jefferson's love for the octagon form, the building predates his architectural work and more likely was selected to encompass the size and shape of pool of mineral spring water,

Covered spring with octagon roof, the Omni Homestead Resort, Hot Springs, Virginia. *Author's collection.*

about 120 feet in circumference. The pool contains approximately forty-three thousand gallons of constantly flowing water. For more water-based activities, you can also hike the Cascades Gorge, a three-hour trail that Jefferson undertook himself in order to pass the time.

For more information, see https://www.omnihotels.com/hotels/homestead-virginia. Bath County also maintains a local history museum, so if you need more history with Jefferson thrown in the mix, head to the Bath County Historical Society, 99 Courthouse Hill Road, Warm Springs, Virginia, 24484, or http://www.bathcountyhistory.org.

# JEFFERSON'S FRIENDS

## JAMES MONROE'S HIGHLAND, MICHIE TAVERN AND JAMES MADISON'S MONTPELIER

Virginians wrote many of the words that gave form and function to the first fifty years of the United States and well beyond. Patrick Henry's "Give Me Liberty, or Give Me Death" speech in Richmond (1775) aroused Patriots to action, while George Mason's Virginia Declaration of Rights (1776) helped Thomas Jefferson to spell out the aggravations of the American colonies toward King George III in the Declaration of Independence (1776). Ten years later, Jefferson's Virginia Statute of Religious Freedom explicated the separation of church and state. Another Virginian, James Madison, helped to construct the United States Constitution (1787), which was based on his earlier work on the Virginia Constitution (1776) and then later added the Bill of Rights (1789) to his brilliant career—and the country's legal framework. The Monroe Doctrine (1823), named for fifth president James Monroe, announced a non-interference position between the Old World and the New.

While there is a place called "Jefferson Country" in the Piedmont of central Virginia, there is also a road called Constitution Route, a National Scenic Byway (Virginia Route 20) that connects Montpelier to Monticello and Highland, the homes of Madison, Jefferson and Monroe. Words and meaning were important to these friends, and friendships between Thomas Jefferson, James Madison and James Monroe were based on mutual respect and enjoyment. Words and ideas traveled over these roads, connecting Virginians. Other Virginian friends, such as Patrick Henry, were not so far away, and Jefferson had many other less well-known friends as well

with whom he corresponded, visited and even designed homes for in the Commonwealth, including James Barbour.

As demonstrated, Thomas Jefferson was many things in his life—he was a Renaissance man in his outlook and abilities, which were able to become fully developed because of his reliance on the backs of the enslaved men, women and children, including his own children with Sally Hemings. But one thing that is often forgotten is that Jefferson was also a dedicated friend to many people, from boyhood to his years as a student, his first forays into government and during the long years of the Revolution and nation-building and nation-governing afterward. In many cases, he cultivated and kept healthy his friendships through extensive letter writing, but on a few occasions, he traveled with friends, such as the extended trip he took to Lake George and points north with James Madison in 1791. He visited them and they him at Monticello. Jefferson also borrowed money from his friends and bought and sold property with his friends, including the sale and purchase of both land and enslaved people. Yet another way to keep his friends close was to encourage them to actually pick up and move to be near him. This is exactly what happened in the case of James Monroe.

## JAMES MONROE'S HIGHLAND

*The scrupulousness of his honor will make you safe in the most confidential communications. A better man cannot be.*

*—Thomas Jefferson to James Madison, May 8, 1784,*
*regarding James Monroe*

Three miles away from Monticello, tucked away at the top of a long curving drive lined with ash trees, sits a house on more than five hundred acres of farm land that, until 2016, was interpreted as James Monroe's house, at one time called Ash Lawn–Highland. This two-story wood clapboard house built onto an older cottage structure is nineteenth century, or Victorian, and dates from a later family who owned the property after Monroe sold the property. For decades, interpreters argued that the smaller cottage structure was all that was left of the original Monroe house, built in 1799. But James Monroe's house and plantation, now called simply Highland, has been through a recent resurrection thanks to the art and science of historical archaeology.

In 2015 and 2016, archaeological excavations and dendrochronology studies determined that the house interpreted as a wing of Monroe's central home was actually a secondary, later house on site and that James Monroe's original home, much larger, existed only under the earth, in ruin, under the boxwood garden. The "upending of history" at Highland is documented in a Google Arts & Culture online exhibit (seen at https://www.google.com/culturalinstitute/beta/partner/james-monroes-highland), which is a great example of how the practice and teaching of history is never static and is constantly open to new interpretations—especially when new technologies allow us to look at old things with new eyes.

*Opposite*:
Driveway up to
James Monroe's
Highland.
*Courtesy James
Monroe's Highland.*

*Right*:
Archaeology at
James Monroe's
Highland.
*Courtesy of Rivanna
Archaeological
Services.*

Monroe was born in 1758, making him more than ten years younger than Thomas Jefferson, but when Monroe went to study law in Richmond in 1780, after studying for two years at the College of William & Mary and then serving as a lieutenant in George Washington's army, he and Jefferson met and quickly became good friends. Such good friends, in fact, that Monroe purchased an eight-hundred-acre property in Charlottesville so that he and his wife, Elizabeth, could be close to Jefferson. Eleven years later, with Monroe practicing law in Albemarle County, the future president purchased a new plantation even closer to Monticello that became known as Highland. Today, Highland is managed by the College of William & Mary, the alma mater

of both Jefferson and Monroe; Monroe attended for two years before leaving to become a soldier in the Continental army. Monroe's original plantation was purchased by the organization working with Jefferson to begin a new college in Charlottesville. A small portion of the original plantation, 43.5 acres, became the land on which the pavilions and range of dormitories were built around the lawn. Monroe was there, with Jefferson and Madison, on October 6, 1817, to lay the cornerstone of Pavilion VII. He was president of the United States at that time.

Madison's contributions to the shape of the United States today were important, although he often followed in Jefferson's footsteps. For example, Monroe was the minister to France during the negotiations of the Louisiana Purchase, he was secretary of state under both Jefferson and Madison and, finally, he was the fifth president of the United States in 1817–25. Unlike

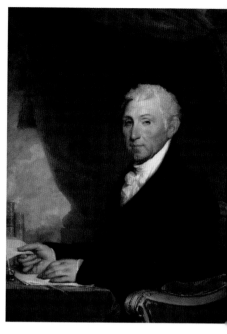

Gilbert Stuart, *Portrait of James Monroe*, oil on canvas, 40¼ x 32 in., circa 1820–22. *Bequest of Seth Lowe, 1916, 29.89. Metropolitan Museum of Art.*

Jefferson, Madison, Washington and Patrick Henry, Monroe is not buried on his plantation (which he left after his wife died) but first in New York City, where he was living with his daughter, and later Richmond, where his body was reinterred in 1858. You can see his grave site monument at Hollywood Cemetery, 412 South Cherry Street and Albemarle, Richmond, Virginia, 23220. Monroe and Jefferson also owned parts of a tract of land in Albemarle County that was called Limestone Plantation. Here was located the Monroe Law Office, used by James Monroe and his brother Andrew. Thomas Jefferson purchased a tract of this land in the 1760s in order to make use of the vein of limestone necessary in the making of mortar, which Jefferson used for both Monticello and the University of Virginia. The structure used by the Monroes is still extant and dates from 1794. You can find the property on Virginia Route 250 in Keswick, Albemarle County, Virginia.

To see Monroe's first plantation site and where the University of Virginia began, view the historical maker on the campus (38° 2.167′N, 78° 30.294′

W). The marker is on McCormick Road south of University Avenue (Business U.S. 250), on the left when traveling south. This spot marks the place where James Monroe acquired his first plantation in Albemarle County in order to be closer to Jefferson. After your campus visit, you can travel across town and up the mountain, passing by Michie Tavern and then Monticello, to James Monroe's Highland, 2050 James Monroe Parkway, Charlottesville, Virginia, 22902. The hours for visiting are 11:00 a.m. to 5:00 p.m., November through March (last tour at 4:00 p.m.) and 9:00 a.m. to 6:00 p.m., April through October (last tour at 5:00 p.m.). James Monroe's Highland also offers a "Slavery at Highland" tour on Fridays and Saturdays and many special programs throughout the year. If you become a fan of James Monroe and want to see and learn more, visit the James Monroe Museum and Library, 908 Charles Street, Fredericksburg, Virginia, 22401. Hours are 10:00 to 5:00 p.m. Monday through Saturday and 1:00 p.m. to 5:00 p.m. on Sundays. The museum and library is managed by the Commonwealth of Virginia via the University of Mary Washington (see http://jamesmonroemuseum.umw.edu).

## MICHIE TAVERN

Historic Michie Tavern served as the social center of its community and accommodated travelers with food, drink and lodging. Located on the drive up to Monticello, Highland, Jefferson Vineyards and other sites of interest, this Virginia landmark captures eighteenth-century life on the road, although today travelers arrive by car and bus, not by horse and buggy. Michie Tavern's dining room features "hearty Midday Fare" in a rustic tavern setting. This means fried chicken, beets, green beans, potatoes and cider to drink. For dessert, try the "Scotch John," which is a pineapple sauce over ice cream—the "Scotch" is a reference to Colonel William Michie's father, John Michie, born in Aberdeen, Scotland, and the original landowner in the Piedmont. William Michie was serving in the Continental army and was at Valley Forge when he received notice that his father was dying. William returned home and opened an ordinary, which was the name for a tavern (you can visit a rustic ordinary, Polly's, at the Peaks of Otter).

In 1779, both William Michie and Thomas Jefferson signed the Albemarle Declaration of Independence—a document now located at the Virginia Historical Society in Richmond, intended to show support to the American

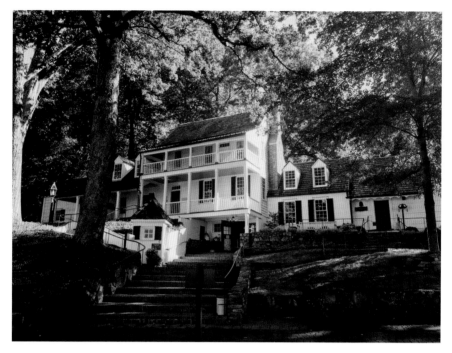

Michie Tavern, Charlottesville, Virginia. *Author's collection.*

Revolution. Although Michie knew Jefferson, the location of his tavern was not on the route to Monticello as it is today. Michie Tavern was purchased, dismantled and moved to the spot by Josephine Henderson, who understood the commercial potential of placing the reconstructed tavern on Carter's Mountain in 1927. Monticello had been opened to the public only a few years earlier, and the automobile was already changing the nature of travel and tourism for Americans.

After eating from the country buffet inside Michie Tavern, step outside to walk the paths for historically infused shopping. The General Store is housed within the Meadow Run Grist Mill, circa 1797, and there is also a clothier, a metal smith shop (which will dazzle you with its shiny objects) and an armory. The tavern has its own gift shop in the lower level. Michie Tavern is a Virginia Historic Landmark. Its hours of operation are seven days a week, year round, from 11:15 a.m. to 3:30 p.m., with special holiday (Thanksgiving and Christmas) dinners. The location is 683 Thomas Jefferson Parkway, Charlottesville, Virginia, 22902. Visit the Michie Tavern website at http://www.michietavern.com.

## JAMES MADISON'S MONTPELIER

*If men were angels, no government would be necessary.*

—*James Madison,* The Federalist *(1788) no. 51*

Before there was Monroe, there was James Madison, a man of smallish stature—he was five-foot-four to Jefferson's six-foot-two—but immense contributions to the construction of the United States. Madison (1751–1836) was a great friend of Thomas Jefferson and his family, staying so frequently at Monticello that one of the guest bedrooms was named in his honor. Born in Orange County, next to Albemarle County, Madison stayed even closer to home than Jefferson, rebuilding his own house, called Montpelier, on the plantation he inherited from his father. Today, the 2,650-acre Montpelier, along the Constitution Route, is less than an hour away from Monticello, but in the late eighteenth century it was a full day's journey (Poplar Forest, in contrast, was three days from Monticello).

Madison and Jefferson were the Virginians most responsible for writing the founding documents of the United States of America. As the youngest of the three who lived near one another in the Piedmont, Monroe continued their work into the early nineteenth century. In the words of the Declaration of Independence, the United States was given a vision and mission statement, while Madison was the primary architect of the Constitution and the Bill of Rights—documents that outlined the structure of government and how it would work. From similar backgrounds, Jefferson and Madison shared their Virginia heritage, love for liberty and religious freedom and a belief in the necessity of an engaged, educated citizenry. As Madison wrote in 1792, "Who are the Best Keepers of the People's Liberties? The people themselves." Like Jefferson, Madison knew the egregious stance of fighting for liberty yet also kept people enslaved for personal benefit.

Like Jefferson, Madison and his wife, Dolley—often a more beloved figure by the American public than her husband, the fourth president—built and rebuilt their large home in the Georgian style, à la Virginia brick, with a large pediment on the façade held up by columns—the architectural style favored by many elites of the eighteenth century. Madison's library was comparable to Jefferson's, although his was used to read accounts of all the other governments in world history in preparation for the drafting of the U.S. Constitution. In this endeavor, Jefferson sent him more books from France to help. The challenge for Madison was to devise a plan that

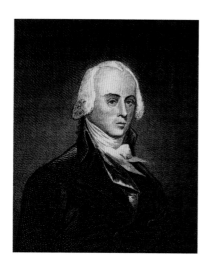

*James Madison*, n.d., line engraving by Parte, black and white, one of two known copies, sheet: 27.5 x 18.5 cm. (10 13/16 x 7 5/16 in.). *Mabel Brady Garvan Collection, Yale University Art Gallery, 1946.9.804.*

would work for thirteen different states, from Maine to Georgia, which had very different population sizes, geographies, economies and pursuits. After reviewing world history, the plan he devised created three branches for the government (executive, legislative and judicial) that would provide checks and balances for the whole system, as well as a House of Representatives elected by the people, with a strong national executive. Madison did his work on the U.S. Constitution while at Montpelier, which like Monticello has a view west of the Blue Ridge Mountains.

James Madison was raised in the immediate vicinity of Montpelier, and like Jefferson, he loved his home dearly and returned there after his presidency, died there and is buried there. Madison was actually James Madison Jr.—the first of twelve children born to Madison Sr. and Nelly Conway. The family owned many books—the primary way young "Jemmy" was schooled in the Piedmont. His father built a new house on a hill that would eventually become Montpelier, and as the oldest male in the family, Madison inherited the property. Like Jefferson, he was sent to school, although for him it was the Tidewater, becoming an excellent student, and unlike Jefferson, he left Virginia to attend the College of New Jersey (eventually Princeton University). Like Jefferson and all of the other elite men of his generation, Madison went to school with his enslaved personal servant, named Sawney. Returning home after school, he became embroiled in the politics of the Tea Party years and soon was a member of the Virginia Committee of Safety and a member of the militia.

In 1776, Madison met Jefferson in Williamsburg, and they became lifelong friends. Madison and Jefferson equally believed in the separation of church and state. Madison wrote the "Memorial and Remonstrance Against Religious Assessments," which helped sway people against a proposed church tax. Jefferson had, ten years earlier in 1775, written the Virginia Statute for Religious Freedom. Jefferson considered this one of

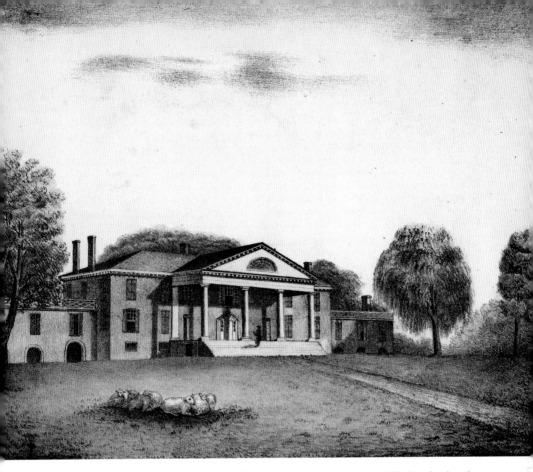

*Mansion of President Madison* (Montpelier, Virginia), n.d., lithograph, partially hand-colored, sheet: 31.5 x 37.8 cm. (12⅜ x 14⅞ in.). *Mabel Brady Garvan Collection, Yale University Art Gallery, 1946.9.1981.*

his "top three" accomplishments in life. Eventually, the U.S. Constitution would reflect this in the First Amendment of the Bill of Rights, drafted by Madison.

Kyle Jenks, a James Madison first-person interpreter who performs at the United States Constitution Center in Philadelphia and other venues, agrees with John F. Kennedy's assessment that Madison is the most underrated president in American history. For Jenks, there are many factors that make Madison's great accomplishments appealing today, but most especially, "Madison was a gentlemen in every sense of the world, revealing his strengths as a statesman and his ability to mediate between polarized factions—a much needed tempering voice in today's current social, economic, political and cultural environment." Jenks also says that "I believe our world can become a better place if this humble man's visions are more widely disseminated.

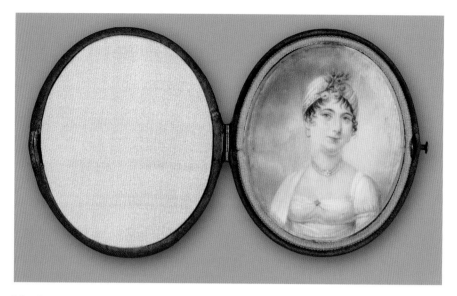

Mrs. James Madison (Dolley Payne, Mrs. James Todd) (1772–1849), circa 1805–10, watercolor on ivory, 2⅜ x 1⅞ in. (6 x 4.8 cm.). *Lelia A. and John Hill Morgan, BA 1893, LLB 1896, MA (Hon.) 1929 Collection, Yale University Art Gallery, 1940.512.*

It is my honor and privilege to deliver his messages and share his life as effectively as extensive research has allowed. The further I delve into Mr. Madison's worldly milieu, the more I am convinced he is our most virtuous founding father."

On the institution of slavery, Madison spoke at the Constitutional Convention in June 1787, "We have seen the mere distinction of color made in the most enlightened period of time, a ground of the most oppressive dominion ever exercised by man over man." And like Jefferson, Madison found the system too profitable to stop and instead was anemic in his abolitionism by becoming a member of the American Colonization Society, whose purpose it was to send freed African Americans to Africa, whether or not they wanted to go. When he died, Madison left his property—including enslaved people—to Dolley. She, in turn, went to live in Washington, D.C., attending society events for another ten years before her passing. She was granted an honorary seat in the House of Representatives and wore clothing dating from the height of fashion twenty years earlier, when she was a young woman just married to James.

The house and the grounds of Montpelier were recently restored by the Montpelier Foundation and the National Trust for Historic Preservation;

2,650 of the original acres remain today and offer a variety of walking trails and gardens to stroll. The house itself is a long, horizontal brick building with a large pediment and portico. Inside, the house has been extensively restored, work that, for almost every historic house museum, never ends. Much like Monticello and Mulberry Row, cabins for enslaved people lined a road behind the house. These cabins, all gone by the twentieth century, are in the process of reconstruction thanks to a major gift from David Rubinstein. Enslaved people who worked in the main house—such as cooks, gardeners, butlers and maids—lived in the cabins closest to the main house and thus were always on call. Enslaved people who worked in the agricultural fields lived near those quarter farms, overseen by a white farm manager or overseer. In order to recover this history, Montpelier has been doing African American genealogy and descendant family work for twenty years. Montpelier is a young organization as compared to George Washington's Mount Vernon, which was opened to the public in 1860, and Thomas Jefferson's Monticello, which opened its doors in 1923. For many years, Montpelier was in private hands—DuPont hands, to be precise—before being turned over to the National Trust for Historic Preservation in 1983.

Madison served as rector of the University of Virginia after Jefferson died, dying ten years later. Like Jefferson and many others of the time, such as Patrick Henry, James Madison is buried on the grounds of his plantation with many others in his family, including his parents and Dolley. Although his and Dolley's grave sites were without formal stone monuments, by the mid-nineteenth century an obelisk (similar to Jefferson's) had been erected at his grave site. On February 17, 1826, less than half a year before his death, Jefferson closed a long letter on the necessity of finding a law professor with acceptably republican principles for his university and of his own dire financial straits, with the touching words: "Take care of me when dead, and be assured I shall leave you with my last affections." Madison replied, following their rule of putting public affairs first in the letter and personal matters last: "You cannot look back to the long period of our private friendship and political harmony, with more affecting resolutions than I do…wishing and hoping that you may yet live to increase the debt which our Country owes you, and to witness the increasing gratitude, which alone can pay it, I offer you the fullest return of affectionate assurances."

Orange County, Virginia, is James Madison country. Montpelier's house and grounds are open seven days a week, and there are choices of different types of tours. The newest tour, called "The Mere Distinction of Color," uses "slavery to connect the past to the present through the lens of the

Constitution, and honestly examines the paradox that is America's founding era," to "Madison & the Constitution," offered on the weekends, with a focus on the document and the man behind its creation. There are also custom-led tours, curatorial tours and behind-the-scenes tours offered, as well as plenty of walking trails to stretch your legs. Visit James Madison's Montpelier at http://www.montpelier.org.

If you need more Madison, you can continue your studies with a visit to the James Madison Museum, where more artifacts and other stories of the fourth president and his wife, Dolley, can be found, including James Madison's Campeche chair, which is displayed alongside President Zachary Taylor's Campeche chair (Thomas Jefferson also had Campeche chairs—you can sit in one at Poplar Forest or buy a reproduction in the Monticello gift shop for a cool $1,895). The small museum is dedicated to sharing stories about not only James and Dolley Madison and six of the eight Virginia-born American presidents but also others in Orange County, such as the exhibit "Forgotten Patriots of the American Revolution," which tells the story of African Americans in the War for Independence. Visit the James Madison Museum at 129 Caroline Street, Orange, Virginia, 22960 and at www.jamesmadisonmuseum.net.

# JEFFERSON'S GRAVE SITE

## MONUMENTS, MEMORY AND MEANING

*No man has greater confidence, than I have, in the spirit of our people.*
*—Thomas Jefferson to James Monroe, October 16, 1814*

ight up until the end of his life, Jefferson was reading and writing letters. Although he still had another year and month to live, Jefferson was aged and sickly when he wrote to Thomas Jefferson Smith, on February 21, 1825, a letter he titled "Counsel to a Nameksake": "This letter will, to you, be as one from the dead. The writer will be in his grave before you can weigh its counsels." In this letter from the end of his life, much like the letter he had sent to Charles Clay for his son Peter in 1817, Jefferson summed up his approach to life, after living it quite thoroughly for eighty-two years: "Adore God. Reverence and cherish your parents. Love your neighbor as yourself, and your country more than yourself. Be just. Be true. Murmur not at the ways of Providence. So shall the life you have entered be the portal to one of eternal and ineffable bliss. And if the dead are permitted to care for the things of this world, every action of your life will be under my regard. Farewell."

Jefferson died, famously, on July 4, 1826, the fiftieth anniversary of the Declaration of Independence. Americans know the story because, like much of Jefferson's personal life, even his death was intertwined with history. He spoke of John Adams that day, an old friend and fellow Patriot who he did not realize died the same day. Jefferson's death was very personal—for his family, for his enslaved family and for the enslaved community who would

Lock of Thomas Jefferson's hair (cut from his head after death), July 4, 1826. *Jefferson-Kirk Manuscripts relating to Thomas Jefferson and the Jefferson and Randolph Families, accession no. 5291, University of Virginia Library, Charlottesville, Virginia.*

be sold upon his death, and it was also very public, since American interest in the third president had never waned and visitors to his house would then want to become visitors to his grave site. Knowing this and shaping right up until the end the message he wanted the public to hear, Jefferson himself laid out specific instructions for his own memorialization in an undated document now located at the Library of Congress. The letter has a drawing of an obelisk and the following statement:

*The following would be to my Manes the most gratifying.*

*On the grave a plain die or cube of 3. f without any mouldings, surmounted by an Obelisk of 6. f. height, each of a single stone: on the faces of the Obelisk the following inscription, & not a word more*

*"Here was buried*
*Thomas Jefferson*
*Author of the Declaration of American Independence*
*Of the Statue of Virginia for religious freedom*
*& Father of the University of Virginia."*

*because by these, as testimonials that I have lived, I wish most to be remembered. to be of the coarse stone of which my columns are made, that no one might be tempted hereafter to destroy it for the value of the materials.*

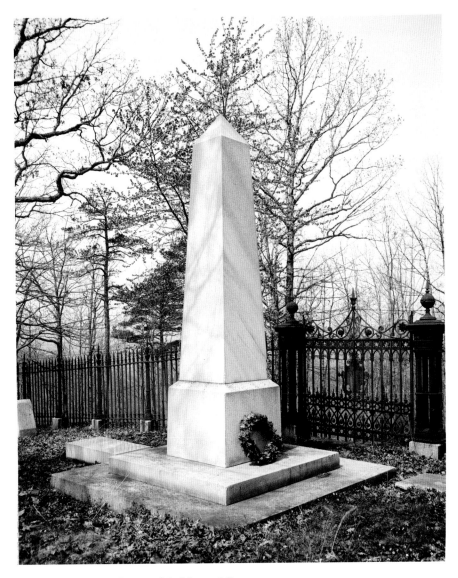

Jefferson's grave site. *Courtesy of the Library of Congress.*

Jefferson drew an obelisk, a tall tapered stone marker that dated directly back to ancient Egypt and was a common form of grave marker in the United States during the late eighteenth and early nineteenth centuries. Despite Jefferson's warnings, the original obelisk was chipped at by visitors to the grave site—it is now at the University of Missouri, due to Jefferson's connection to the Lewis and Clark Expedition. A new obelisk was installed

Exterior ironwork gate around the Monticello Graveyard. The exterior gate—very tall—indicates a later date for installation, likely in 1883, the date the second obelisk for Thomas Jefferson was installed after the first had been damaged by souvenir hunters. The gate features the initials "TJ" in a fanciful Neoclassical brass medallion. *Courtesy of Susan McCall.*

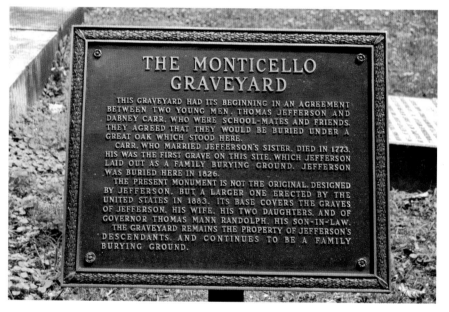

# THE MONTICELLO GRAVEYARD

THIS GRAVEYARD HAD ITS BEGINNING IN AN AGREEMENT BETWEEN TWO YOUNG MEN, THOMAS JEFFERSON AND DABNEY CARR, WHO WERE SCHOOL-MATES AND FRIENDS. THEY AGREED THAT THEY WOULD BE BURIED UNDER A GREAT OAK WHICH STOOD HERE.

CARR, WHO MARRIED JEFFERSON'S SISTER, DIED IN 1773. HIS WAS THE FIRST GRAVE ON THIS SITE, WHICH JEFFERSON LAID OUT AS A FAMILY BURYING GROUND. JEFFERSON WAS BURIED HERE IN 1826.

THE PRESENT MONUMENT IS NOT THE ORIGINAL, DESIGNED BY JEFFERSON, BUT A LARGER ONE ERECTED BY THE UNITED STATES IN 1883. ITS BASE COVERS THE GRAVES OF JEFFERSON, HIS WIFE, HIS TWO DAUGHTERS, AND OF GOVERNOR THOMAS MANN RANDOLPH, HIS SON-IN-LAW.

THE GRAVEYARD REMAINS THE PROPERTY OF JEFFERSON'S DESCENDANTS, AND CONTINUES TO BE A FAMILY BURYING GROUND.

Monticello Graveyard sign. Although viewers can peer through the gates, the graveyard at Monticello is locked for safety. The graveyard continues to be used by Jefferson family members. *Courtesy of Susan McCall.*

in Monticello's cemetery in 1883. It's likely that a lot of chipping happened in 1876, which was the centennial of the new country.

Events were held all over the country, although the largest celebration was in Philadelphia with the Centennial Exposition, but every American town, city or historic site with a connection to the American Revolution was shined and buffed—new monuments were put in place and pamphlets, books and

Henry Dean, *Untitled (Allegorical Portrait of Thomas Jefferson)*, 1807, etching and engraving with stippling, 15 11/16 x 18 in. *Mabel Brady Garvan Collection, Yale University Art Gallery, 1946.9.870.*

prints about the Revolution were printed and dispersed and Thomas Jefferson was often seen with the inner circle of Founding Fathers, of which George Washington always reigned supreme. In one untitled print from earlier in the century, the special relationship Americans created for Washington and Jefferson—the sword and the pen of the Revolution—is seen in the roundel portrait of Washington on an obelisk, which looks down on another portrait, this one of Jefferson, being held by Lady Liberty. Images like this created a narrative that held sway for a long time. The United States had a bicentennial in 1976, and again, images of Washington, Jefferson, Lafayette and others circulated in the public sphere—even landing on Broadway in the musical *1776*, from which Lin-Manuel Miranda's *Hamilton* is a successor.

But for all of the pictures and parades, musicals and monuments the United States has produced since the end of the Revolution, through his

Thomas Gimbrede (American, 1781–1832), *Washington, Jefferson, Madison and Adams*, 1812, Stipple engraving, black and white, first state of 2, sheet: 25.5 x 31.5 cm. (10 1/16 x 12⅜ in.). *Mabel Brady Garvan Collection, Yale University Art Gallery, 1946.9.977.*

self-written epitaph Thomas Jefferson told us what we should be thinking about on his gravestone—thus, it's a good idea to revisit these words and think about them and how his words set out a sort of mission statement for a new country where equality and education were the primary ideas around which to organize. Strong belief in the rational mind, in learning and in purposeful work enabled Jefferson to trust in the "spirit of our people," as he wrote to friend James Monroe in 1814. Like any organization with a mission statement, Americans might ask themselves: How have we measured up over the past (almost) 250 years? Are we getting closer to fulfilling the promise of "Life, Liberty and the Pursuit of Happiness" for everyone? Do we need to refine these ideas again to make them work in better ways? A section deleted by members of the Continental Congress, discussing the "assemblage of horrors" of the slave trade, is emphasized in its original position here—a reminder that Americans have been struggling with these questions since the very beginning of the country (and before).

*In Congress, July 4, 1776*

THE UNANIMOUS DECLARATION *of the thirteen united States of America.*

*When, in the course of human events, it becomes necessary for one people to dissolve the political bonds which have connected them with another, and to assume among the powers of the earth, the separate and equal station to which the laws of nature and of nature's God entitle them, a decent respect to the opinions of mankind requires that they should declare the causes which impel them to the separation.*

*We hold these truths to be self-evident, that all men are created equal, that they are endowed by their Creator with certain unalienable rights, that among these are life, liberty and the pursuit of happiness. That to secure these rights, governments are instituted among men, deriving their just powers from the consent of the governed. That whenever any form of government becomes destructive to these ends, it is the right of the people to alter or to abolish it, and to institute new government, laying its foundation on such principles and organizing its powers in such form, as to them shall seem most likely to effect their safety and happiness. Prudence, indeed, will dictate that governments long established should not be changed for light and transient causes; and accordingly all experience hath shown that mankind are more disposed to suffer, while evils are sufferable, than to right themselves by abolishing the forms to which they are accustomed. But when a long train of abuses and usurpations, pursuing invariably the same object evinces a design to reduce them under absolute despotism, it is their right, it is their duty, to throw off such government, and to provide new guards for their future security.*

*Such has been the patient sufferance of these colonies; and such is now the necessity which constrains them to alter their former systems of government. The history of the present King of Great Britain is a history of repeated injuries and usurpations, all having in direct object the establishment of an absolute tyranny over these states. To prove this, let facts be submitted to a candid world.*

*He has refused his assent to laws, the most wholesome and necessary for the public good.*

*He has forbidden his governors to pass laws of immediate and pressing importance, unless suspended in their operation till his assent should be obtained; and when so suspended, he has utterly neglected to attend to them.*

John Trumbull, *The Declaration of Independence, July 4, 1776*, 1786–1820, oil on canvas, 20⅛ x 31 in. American Patriot and painter John Trumbull visited with each of the surviving members of the Continental Congress over the course of decades, painting individual portraits of each member and creating a series of large-scale paintings that told the story of the American Revolution. Thomas Jefferson invited Trumbull to stay with him in Paris and drew a sketch of the room, which Trumbull used to lay the most famous scene—one that would eventually appear on the reverse of the two-dollar bill, with Jefferson's portrait on the front. *Trumbull Collection, Yale University Art Gallery, 1832.3.*

*He has refused to pass other laws for the accommodation of large districts of people, unless those people would relinquish the right of representation in the legislature, a right inestimable to them and formidable to tyrants only.*

*He has called together legislative bodies at places unusual, uncomfortable, and distant from the depository of their public records, for the sole purpose of fatiguing them into compliance with his measures.*

*He has dissolved representative houses repeatedly, for opposing with manly firmness his invasions on the rights of the people.*

*He has refused for a long time, after such dissolutions, to cause others to be elected; whereby the legislative powers, incapable of annihilation, have returned to the people at large for their exercise; the state remaining in the meantime exposed to all the dangers of invasion from without, and convulsions within.*

*He has endeavored to prevent the population of these states; for that purpose obstructing the laws for naturalization of foreigners; refusing to pass others to encourage their migration hither, and raising the conditions of new appropriations of lands.*

*He has obstructed the administration of justice, by refusing his assent to laws for establishing judiciary powers.*

*He has made judges dependent on his will alone, for the tenure of their offices, and the amount and payment of their salaries.*

*He has erected a multitude of new offices, and sent hither swarms of officers to harass our people, and eat out their substance.*

*He has kept among us, in times of peace, standing armies without the consent of our legislature.*

*He has affected to render the military independent of and superior to civil power.*

*He has combined with others to subject us to a jurisdiction foreign to our constitution, and unacknowledged by our laws; giving his assent to their acts of pretended legislation:*

*For quartering large bodies of armed troops among us:*

*For protecting them, by mock trial, from punishment for any murders which they should commit on the inhabitants of these states:*

*For cutting off our trade with all parts of the world:*

*For imposing taxes on us without our consent:*

*For depriving us in many cases, of the benefits of trial by jury:*

*For transporting us beyond seas to be tried for pretended offenses:*

*For abolishing the free system of English laws in a neighboring province, establishing therein an arbitrary government, and enlarging its boundaries so as to render it at once an example and fit instrument for introducing the same absolute rule in these colonies:*

*For taking away our charters, abolishing our most valuable laws, and altering fundamentally the forms of our governments:*

*For suspending our own legislatures, and declaring themselves invested with power to legislate for us in all cases whatsoever.*

*He has abdicated government here, by declaring us out of his protection and waging war against us.*

*He has plundered our seas, ravaged our coasts, burned our towns, and destroyed the lives of our people.*

*He is at this time transporting large armies of foreign mercenaries to complete the works of death, desolation and tyranny, already begun with circumstances of cruelty and perfidy scarcely paralleled in the most barbarous ages, and totally unworthy the head of a civilized nation.*

*He has constrained our fellow citizens taken captive on the high seas to bear arms against their country, to become the executioners of their friends and brethren, or to fall themselves by their hands.*

*He has excited domestic insurrections amongst us, and has endeavored to bring on the inhabitants of our frontiers, the merciless Indian savages, whose known rule of warfare, is undistinguished destruction of all ages, sexes and conditions.*

He has waged cruel war against human nature itself, violating its most sacred rights of life and liberty in the persons of a distant people who never offended him, captivating and carrying them into slavery in another hemispere, or to incure miserable death in their transportation hither. This piratical warfare, the opprobium of infidel powers, is the warfare of the Christian king of Great Britain. [Determined to keep open a market where Men should be bought and sold,] he has prostituted his negative for suppressing every legislative attempt to prohibit or to restrain this execrable commerce: and that this assemblage of horrors might want no fact of distinguished die, he is now exciting those very people to rise in arms among us, and to purchase that liberty of which he had deprived them, by murdering the people upon whom he also obtruded them: thus paying off former crimes committed against the liberties of one people, with crimes which he urges them to commit against the lives of another.

*In every stage of these oppressions we have petitioned for redress in the most humble terms: our repeated petitions have been answered only by repeated injury. A prince, whose character is thus marked by every act which may define a tyrant, is unfit to be the ruler of a free people.*

*Nor have we been wanting in attention to our British brethren. We have warned them from time to time of attempts by their legislature to extend an unwarrantable jurisdiction over us. We have reminded them of the circumstances of our emigration and settlement here. We have appealed to their native justice and magnanimity, and we have conjured*

*them by the ties of our common kindred to disavow these usurpations, which, would inevitably interrupt our connections and correspondence. We must, therefore, acquiesce in the necessity, which denounces our separation, and hold them, as we hold the rest of mankind, enemies in war, in peace friends.*

*We, therefore, the representatives of the United States of America, in General Congress, assembled, appealing to the Supreme Judge of the world for the rectitude of our intentions, do, in the name, and by the authority of the good people of these colonies, solemnly publish and declare, that these united colonies are, and of right ought to be free and independent states; that they are absolved from all allegiance to the British Crown, and that all political connection between them and the state of Great Britain, is and ought to be totally dissolved; and that as free and independent states, they have full power to levy war, conclude peace, contract alliances, establish commerce, and to do all other acts and things which independent states may of right do. And for the support of this declaration, with a firm reliance on the protection of Divine Providence, we mutually pledge to each other our lives, our fortunes and our sacred honor.*

Indicating Virginia's long interest in preserving its own history, six of the seven houses of the signers of the Declaration of Independence are historic sites open to the public—and the only reason the seventh signer's house isn't open is because the house burned to the ground. If you'd like to visit the homes of the Virginia signers of the Declaration of Independence, five are managed by private, not-for-profit organizations, with the sixth managed by the federal government in the case of Thomas Nelson Jr.'s house, which is part of Colonial National Historical Park. In addition to Thomas Jefferson's Monticello and Poplar Forest, you can visit George Wythe's house in Colonial Williamsburg; Francis Lightfoot Lee's house, Menokin (an unusual story of historic preservation in Richmond County); Richard Henry Lee's Stratford Hall, in Westmoreland County; Benjamin Harrison's birthplace, the Berkeley Plantation, in Charles City County; and Thomas Nelson Jr., who lived in Nelson House during the Revolutionary War, in Yorktown, a site now maintained by the National Park Service. As mentioned, the house of the seventh signer, Carter Braxton, a somewhat reluctant revolutionary, burned, although there is an archaeological site with the remains of the original plantation that can be visited, called Newington Archaeological Site, in King and Queen County, Virginia.

# STATUE OF RELIGIOUS FREEDOM FOR VIRGINIA (1786)

*Whereas, Almighty God hath created the mind free;*

*That all attempts to influence it by temporal punishments or burthens, or by civil incapacitations tend only to beget habits of hypocrisy and meanness, and therefore are a departure from the plan of the holy author of our religion, who being Lord, both of body and mind yet chose not to propagate it by coercions on either, as was in his Almighty power to do,*

*That the impious presumption of legislators and rulers, civil as well as ecclesiastical, who, being themselves but fallible and uninspired men have assumed dominion over the faith of others, setting up their own opinions and modes of thinking as the only true and infallible, and as such endeavouring to impose them on others, hath established and maintained false religions over the greatest part of the world and through all time;*

*That to compel a man to furnish contributions of money for the propagation of opinions, which he disbelieves is sinful and tyrannical;*

*That even the forcing him to support this or that teacher of his own religious persuasion is depriving him of the comfortable liberty of giving his contributions to the particular pastor, whose morals he would make his pattern, and whose powers he feels most persuasive to righteousness, and is withdrawing from the Ministry those temporary rewards, which, proceeding from an approbation of their personal conduct are an additional incitement to earnest and unremitting labours for the instruction of mankind;*

*That our civil rights have no dependence on our religious opinions any more than our opinions in physics or geometry,*

*That therefore the proscribing any citizen as unworthy the public confidence, by laying upon him an incapacity of being called to offices of trust and emolument, unless he profess or renounce this or that religious opinion, is depriving him injuriously of those privileges and advantages, to which, in common with his fellow citizens, he has a natural right,*

*That it tends only to corrupt the principles of that very Religion it is meant to encourage, by bribing with a monopoly of worldly honours and emoluments those who will externally profess and conform to it;*

*That though indeed, these are criminal who do not withstand such temptation, yet neither are those innocent who lay the bait in their way;*

*That to suffer the civil magistrate to intrude his powers into the field of opinion and to restrain the profession or propagation of principles on supposition of their ill tendency is a dangerous fallacy which at once*

*destroys all religious liberty because he being of course judge of that tendency will make his opinions the rule of judgment and approve or condemn the sentiments of others only as they shall square with or differ from his own;*

*That it is time enough for the rightful purposes of civil government, for its officers to interfere when principles break out into overt acts against peace and good order;*

*And finally, that Truth is great, and will prevail if left to herself, that she is the proper and sufficient antagonist to error, and has nothing to fear from the conflict, unless by human interposition disarmed of her natural weapons free argument and debate, errors ceasing to be dangerous when it is permitted freely to contradict them:*

*Be it enacted by General Assembly that no man shall be compelled to frequent or support any religious worship, place, or ministry whatsoever, nor shall be enforced, restrained, molested, or burthened in his body or goods, nor shall otherwise suffer on account of his religious opinions or belief, but that all men shall be free to profess, and by argument to maintain, their opinions in matters of Religion, and that the same shall in no wise diminish, enlarge or affect their civil capacities. And though we well know that this Assembly elected by the people for the ordinary purposes of Legislation only, have no power to restrain the acts of succeeding Assemblies constituted with powers equal to our own, and that therefore to declare this act irrevocable would be of no effect in law; yet we are free to declare, and do declare that the rights hereby asserted, are of the natural rights of mankind, and that if any act shall be hereafter passed to repeal the present or to narrow its operation, such act will be an infringement of natural right.*

# CODA

The concept that history is permanent is only loosely true. It is up to the current generation to decide how to interpret history, and those interpretations evolve over time. One generation might revere a man or an ideal or a flag, and then the next generation might revile those very same symbols. In these moments, the symbols do not change. Our opinions change. Even seemingly concrete examples of history, like names and dates, may change over time. For an example of this, one needs only look at Jefferson's grave marker. Was he born on April 2 or April 13? The answer depends on how Jefferson interpreted history and how the will of the current generation interprets history.

In the third book of Jean-Jacques Rousseau's foundational work *The Social Contract*, he speaks of the three wills that each apply pressure on government. One of these wills he calls the general will, which brings to mind a will of the majority; indeed he is speaking of, as he says, the will of "the people." Thomas Jefferson read and loved *The Social Contract*. In fact, if you were to pick up a copy of that seminal work, you would find entire chapters that, to us, feel like American canon, yet to the minds of eighteenth-century readers, it was revolutionary. Again we see that the subject matter has not changed from the eighteenth century to the twenty-first, but rather our opinions, specifically in regards to the audacity or mundanity, have changed. So, what does this evolution of opinion mean to we the people? Simply, we are the momentary custodians of our history. It is up to us to revere, revile, exonerate, defend or prosecute our history. And to do that, we must more

deeply comprehend history. We become custodians of nothing if we choose the path of ignorance.

My job is to help hold up a bulwark against apathy and ignorance. My job is to read Thomas Jefferson's words and present them in a format in which modern audiences find relevance, meaning and hopefully action through civic engagement. I don't have to reach far to make his words relevant. In the eighteenth century, we were speaking of religion, inequality, constitutionality of laws and states' rights versus federal rights. We are still speaking of those topics today. They remain extant examples planted on tables of statehouses and just as firmly planted on our domestic dinner tables. We are entrenched in the daily rock of our ship of state from the moment we wake up and check the news on our smartphones. We talk about politics around the water cooler. We fill our cars with gasoline while the world's news reverberates over oil-soaked concrete. At these moments of mundanity, we may easily fall into one of the traps of self-government: the utilization of hot passion over cool reason. This is precisely why we warn our relatives to remain silent about politics while family is gathered for the holidays, as hot passion often presides where cool reason should. When we fall into this trap, we not only cease conversation, we cease forward motion. We stagnate. My job, as a first-person interpreter of Jefferson, is to facilitate all opinions toward mutual, respectful and mature conversation of the past so we might become better stewards of our future. This is a delicate task, but I have Jefferson's words in my corner. And I have an incomparable mentor, Bill Barker.

Bill has portrayed Thomas Jefferson longer than I have been alive and is undoubtedly one of the world's preeminent scholars on the "man of the people." Thomas was blessed with mentors who "fixed his destinies" throughout his life. Just as Thomas Jefferson stood on the shoulders of giants who stood before him, so do we, as custodians of our history, carry the torch of mankind's mutual experience into the next generation. Bill Barker has an unbelievable comprehension of Jefferson, a Samaritan's sense of kindness when passing that comprehension along and a serene lack of egotistical attachment to a character he has portrayed for thirty years. Bill is a mentor. More than simply pointing me in the right direction to understanding Jefferson, he is a mentor in how to be a kind and generous human. It is up to me to continue carrying the torch. It is up to all of us to comprehend history in a one-thousand-year arc so that we may more deeply understand how our contemporary will influences our treatment of that history. It is up to we the people to utilize history to make ourselves better.

Every good book leaves you in the same state as every good teacher—with more questions than answers. And so we must ask ourselves the following:

- What is the lens with which we are currently viewing history?
- What is the current general will of the sovereign people?
- What are we currently slaves to that impedes our gradual progress toward a more perfect, harmonious freedom?

If we solve these questions through a mutual conversation of cool reason, we are well on our way toward another 241 years under this republic.

KURT SMITH

# ACKNOWLEDGEMENTS

*The steady character of our countrymen is a rock to which we may safely moor.*
*—Thomas Jefferson to Elbridge Gerry, March 29, 1801*

S o many books, so little time" goes the phrase printed on sweatshirts and book bags. So many acknowledgments and just enough time. For this work, I thank first and foremost Kate Jenkins, commissioning editor at The History Press, for her great enthusiasm for the project and shared approach and love for making history available for everyone to study and enjoy. Thanks also to Anna Burrous, who designed the book and map, and Ryan Finn, who addressed the final editing of the manuscript. The staff of the United Parcel Service at Boonsboro, especially Mark Miller and Christy Sandidge, are also given a shout-out here—their services have brought me from book one all the way through to this, book six. They are terrific. At Lafayette College, Michiko Okaya and David Burnhauser were helpful, as was Marianne Martin at the Rockefeller Library at Colonial Williamsburg. Artist Suzanne Stryk and photographer Susan McCall generously shared their work with me for this book. Many thanks to Marcia Strait, a sometime historian for Bleinheim Vineyards who shared with me the history of the vineyard and its Jefferson connections. Thanks to Kyle Jenks (and his sidekick, Little Jemmy), who relishes interpreting the life of James Madison and whose thoughts appear in the chapter on Montpelier. In line with thanking those who don historic costume in order to bring the past to the present, many thanks go to Bill Barker and Kurt Smith,

who together interpret Thomas Jefferson at Colonial Williamsburg. Both share their enormous knowledge and talent whenever and wherever they are asked. Their contributions to this book serve as insightful and stirring bookends.

At Thomas Jefferson's Poplar Forest, I thank the staff for sharing their work and resources: Cheryl Childress, David Clauss, Vincent Fastabend, Brian Foree, Rachel Honchul, Wayne Gannaway, Jack Gary, Mary Kesler, Kathy Kramer, Mary Massie, Travis McDonald, Karen McIlvoy, Tammy Moss, Alyson Ramsey, Jennifer Ogborne, Eric Proebsting, Karen Warren and Stormy Wiegand. Special thanks to Gail Pond, who ably watches over a small but solid resource library at Poplar Forest. Finally—always mentioned last but never least—the talents, hard work and generous nature of Jeffrey Leigh Nichols is more appreciated than he knows. He is the rock to which I am safely moored. How grateful I am to not only watch Thomas Jefferson's Poplar Forest grow over the past five years to become a more inclusive and robust historic site but also experience life in the Commonwealth of Virginia and, specifically, in Jefferson Country, which is a combination of great natural beauty and layers of history that have shaped not only the land but also the country as a whole and beyond.

# BRIEF CHRONOLOGY OF THOMAS JEFFERSON'S LIFE AND WORK IN VIRGINIA AND FOR THE UNITED STATES

April 13, 1743: Thomas Jefferson is born at Shadwell, in Virginia.

1757: Peter Jefferson, Thomas's father, dies at age fifty. Thomas is fourteen.

1760: Thomas Jefferson becomes a student at the College of William & Mary in Williamsburg.

1762: Jefferson begins law studies with George Wythe in Williamsburg.

1767: Jefferson is admitted to the bar and begins work on Monticello.

1768: Jefferson is elected to the House of Burgesses for the Colony of Virginia.

1772: Jefferson marries Mrs. Martha Wayles Skelton on January 1; later that year, their first daughter, Martha "Patsy" Jefferson, is born.

1773: Jefferson inherits Poplar Forest after the death of his father-in-law.

1774: Parliament closes the Boston port to trade after the Tea Party; Jefferson suggests a day of prayer in protest; the First Continental Congress meets; second daughter, Jane Randolph, is born (but lives less than two years).

1775: The Second Virginia Convention meets; Patrick Henry gives the speech "Give Me Liberty, or Give Me Death"; the British governor leaves Virginia.

1776: British army burns Norfolk, Virginia; Jefferson writes the Declaration of Independence; Jefferson and Wythe begin revision to Virginia laws.

1777: Jefferson's first son is born but dies in seventeen days; Jefferson drafts the Virginia Statute of Religious Freedom (adopted 1786).

1778: Jefferson's third daughter, Mary "Polly" Jefferson, is born.

1779: Jefferson succeeds Patrick Henry as governor of Virginia.

1780: Jefferson moves the capital of Virginia from Williamsburg to Richmond for safety from the British army (farther inland, away from water); fourth daughter, Lucy Elizabeth Jefferson, is born.

1781: Richmond is invaded by British; Jefferson flees to Monticello and farther to Poplar Forest, where he begins writing *Notes on the State of Virginia*; Lucy dies at age five months; Jefferson resigns governorship.

1782: Another daughter, again named Lucy, is born to Thomas and Martha Jefferson; Martha dies and is buried in the cemetery at Monticello

1783: The Revolutionary War ends; Jefferson is elected to Congress.

1784: Jefferson is appointed minister plenipotentiary to France; he leaves for five years, taking Patsy and enslaved people with him; Lucy Jefferson dies.

1785: Jefferson succeeds Benjamin Franklin as minister to France; *Notes on the State of Virginia* is published.

1790: Jefferson becomes George Washington's first secretary of state.

1791: Jefferson helps plan the new capital city of Washington, D.C.

1796: Jefferson is elected vice president of the United States.

1801: Jefferson is elected president of the United States after a tie with Aaron Burr.

1803: Jefferson authorizes the Lewis and Clark Expedition.

1804: Mary Jefferson Eppes, called Polly, dies.

1805: Jefferson begins second presidential term.

1806: Jefferson begins work on octagon house at Poplar Forest.

1809: Jefferson finishes public service and returns to Monticello.

1814: British burn the U.S. Capitol Building in Washington, D.C.; Jefferson sells his personal library to Congress; Jefferson begins work on the Albemarle Academy, which becomes the University of Virginia.

1825: The Marquis de Lafayette visits Jefferson as UVA opens for first class of students.

July 4, 1826: The fiftieth anniversary of the Declaration of Independence is celebrated; Thomas Jefferson and longtime friend John Adams both die; Jefferson is buried at Monticello.

# BIBLIOGRAPHY

Not surprisingly, considering the connection to Thomas Jefferson, the Library of Congress owns the largest collection of Jefferson material in the world. Thanks to its continuously growing digitization program and online exhibit work, people from around the globe can access these resources for free. Visit https://www.loc.gov/rr/program/bib/presidents/jefferson as your starting point to its deep resources on his life in letters and documents. Other repositories with large collections of primary Jefferson material include the Massachusetts Historical Society, the Albert and Shirley Small Special Collections Library at the University of Virginia and the Thomas Jefferson Foundation Inc., the not-for-profit organization that manages Monticello. Many of the sites associated with Jefferson and discussed in this book also have archival documents and material culture from his life and legacy. Studying Thomas Jefferson is, for some, a lifetime endeavor. What we know about him changes, but so does our interpretation of him and his place in the history of Virginia, the United States and the world.

Arnold, David Scott, comp. *A Guidebook to Virginia's Historical Markers*. 3rd edition. Charlottesville: University of Virginia Press, 2007.

Bear, James A., Jr. *Jefferson's Memorandum Books, Accounts with Legal Records and Miscellany*. Princeton, NJ: Princeton University Press, 1997.

Bence, Evelyn, ed. *James Madison's Montpelier*. Montpelier, VT: Montpelier Foundation, 2008.

Betts, Edwin Morris, ed. *Thomas Jefferson's Farm Book*. Charlottesville, VA: University of Virginia Press, 1987.

———. *Thomas Jefferson's Garden Book, 1766–1824*. Philadelphia: American Philosophical Society, 1985.

Brownell, Charles. "The Jeffersonian Courthouse in Virginia, 1810–1850." NHL Thematic Nomination Project, Virginia Commonwealth University Graduate Seminar ARTH 789, "The World of Jefferson and Latrobe" (2003). Richmond, Virginia, May 2006.

Crotty, Gene. *Jefferson's Western Travels Over Virginia's Blue Ridge Mountains*. N.p.: privately printed, 2002.

Ellis, Joseph J. *American Sphinx: The Character of Thomas Jefferson*. New York: Vintage Books, 1996.

Gary, Jack. "Acquiring Transfer-Printed Ceramics for the Jefferson Household at Poplar Forest." *Material Worlds: Archaeology, Consumption, and the Road to Modernity.* Edited by Barbara Heath, Eleanor Breen and Lori Lee. Florence, KY: Routledge Press, 2017.

Grafton, John, ed. *The Declaration of Independence and Other Great Documents of American History, 1775–1865*. Mineola, NY: Dover Publications Inc., 2000.

Heath, Barbara J. *Hidden Lives: The Archaeology of Slave Life at Thomas Jefferson's Poplar Forest*. Charlottesville: University Press of Virginia, 1999.

Holmes, John M. *Thomas Jefferson Treats Himself*. Fort Valley, VA: Loft Press Inc., 1997.

Horn, Joan L. *Thomas Jefferson's Poplar Forest: A Private Place*. Forest, VA: Corporation for Jefferson's Poplar Forest, 2002.

Howard, Hugh. *Thomas Jefferson, Architect: The Built Legacy of Our Third President*. New York: Rizzoli, 2003.

Kimball, Fiske. *The Capitol of Virginia: A Landmark of American Architecture*. Richmond: Virginia State Library and Archives, 1989.

Maas, John. *George Washington's Virginia*. Charleston, SC: The History Press, 2017.

———. *The Road to Yorktown: Jefferson, Lafayette and the British Invasion of Virginia*. Charleston, SC: The History Press, 2016.

Marley, Anna O. "Landscapes of the New Republic at Thomas Jefferson's Monticello." *Building the British Atlantic World, Spaces, Places, and Material Culture, 1600–1850*. Chapel Hill: University of North Carolina Press, 2016.

Miller, Charley, and Peter Miller. *Monticello: The Official Guide to Thomas Jefferson's World*. Washington, D.C.: National Geographic and the Thomas Jefferson Foundation, 2016.

Onuf, Peter S. "The Scholars' Jefferson." *William and Mary Quarterly* 50, no. 4, 3rd Series (October 1993): 671–99.

Peden, William, ed. *Notes on the State of Virginia by Thomas Jefferson.* Williamsburg, VA: Omohundro Institute of Early American History and Culture, 1982.

Reed, B. Bernetiae. *The Slave Families of Thomas Jefferson: A Pictorial Study Book with an Interpretation of His Farm Book in Genealogy Charts.* Vols. 1 and 2. N.p.: Sylvest-Sarah Inc., 2007.

Stein, Susan R. *The Worlds of Thomas Jefferson at Monticello.* New York: Harry N. Abrams Inc., 1993.

Wiencek, Henry. *The Smithsonian Guide to Historic America: Virginia and the Capital Region.* Washington, D.C.: Smithsonian Books, 1989.

# INDEX

# ABOUT THE AUTHOR

Laura A. Macaluso, PhD, researches and writes about murals, monuments, museums and material culture. She has degrees in art history and the humanities from Southern Connecticut State University, Syracuse University in Italy and Salve Regina University. Originally a Connecticut Yankee, she has been living in the Commonwealth of Virginia for the past five years. This is her third book for The History Press. In 2018, her dissertation, *The Public Artscape of New Haven: Themes in the Creation of a City Image* (McFarland & Company Inc.) will be published, as will *Monument Culture: International Perspectives on the Future of Monuments in a Changing World* (American Association for State and Local History, Rowman & Littlefield), for which she is the editor. She is a grants writer for arts organizations in central Virginia, New York and Connecticut.

## ABOUT THE FOREWORD AND CODA CONTRIBUTORS

Bill Barker and Kurt Smith each portray Thomas Jefferson for the Colonial Williamsburg Foundation and at Jefferson-related historic sites and other events.

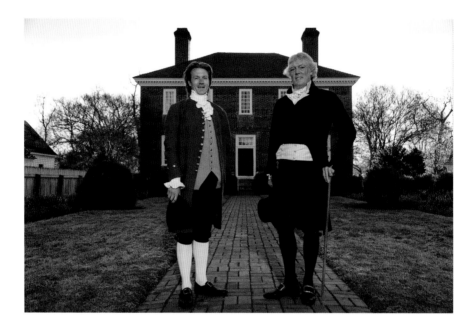

BILL BARKER (*right*) has portrayed Thomas Jefferson in a variety of settings for nearly thirty years. A historian who was attracted to the stage at an early age, Barker was cast as Jefferson in many different venues, including the musical *1776*. The professional actor, director and producer, who is the same height and weight as Jefferson and has the same general appearance, has portrayed Jefferson at Colonial Williamsburg since 1993 and has developed an extensive repertoire of Jefferson presentations. He has performed as Thomas Jefferson at Poplar Forest, Monticello, the White House and the Palace of Versailles; at numerous venues throughout the United States, Great Britain and France; and on numerous television programs.

KURT SMITH (*left*) portrays the brilliant, provocative and, at times, paradoxical Thomas Jefferson for the Colonial Williamsburg Foundation. Kurt has traveled the country while acting. He has played a lead character in an Emmy Award–winning TV series, he has created characters for Pulitzer finalists, collaborated with Tony Award winners on new plays and co-written a nationally awarded play through the Kennedy Center, and now he hopes to spend the rest of his life becoming a deep friend of Thomas Jefferson. He loves the mild weather Virginia offers but wants to eradicate all mosquitoes.

*Visit us at*
www.historypress.com